SAMUEL PALMER
SHOREHAM AND AFTER

CARLOS PEACOCK

SAMUEL PALMER
Shoreham and After

JOHN BAKER

5 ROYAL OPERA ARCADE

PALL MALL, LONDON, S.W.1

First published 1968
by John Baker (Publishers) Ltd
5 Royal Opera Arcade, Pall Mall
London, S.W.1

S.B.N. 212 . 99817 . X

Printed in Great Britain by
W & J Mackay & Co Ltd, Chatham

To the memory of my great-aunt,
Ada Hanbury,
Victorian painter and naturist,
a contemporary of
Samuel Palmer

L

CONTENTS

ILLUSTRATIONS

IN THE TEXT

THE PLATES

COLOUR

MONOCHROME

3 Oak Trees in Lullingstone Park, Kent. Pen and ink, and water-colour.
 National Gallery of Canada

4 A Shepherd leading his Flock under the Full Moon. Sepia.
 Collection: L. G. Duke

5 Woman and Deer under a Full Moon. Body colour and sepia wash.
 Victoria and Albert Museum

6 Tintern Abbey. Pencil heightened with body colour.
 Collection: George Goyder

7 View at Linton, Devon. Pencil and water-colour.
 Spooner Collection

8 The Young Angler. Water-colour.
 National Gallery of Canada

9 View on the River Machawy, North Wales. Black chalk and water-colour.
 Manning Gallery

10 Classical Subject. Water-colour.
 Collection: R. J. Philips

11 Pistyll Rhaiadr, North Wales. Water-colour.
 Spooner Collection

12 View from the Villa D'Este, Tivoli. Water-colour.
 Collection: E. Thomson

13 Lulworth Cove, Dorset. Pencil and water-colour.
 Collection: Lady Eldon

14 Christ outside Jerusalem. Oil.
 Private collection

15 Landscape with Rain-cloud. Pencil and water-colour.
 Maas Gallery

16 Coast at Lynmouth, Devon. Pencil and water-colour.
 Collection: Benjamin Britten

17 Study of Waves breaking on the Sea-shore. Pencil.
 National Gallery of Canada

18 Tintagel Castle: Approaching Rain. Pencil and water-colour.
 Ashmolean Museum, Oxford

19 Truro River. Pencil and water-colour.
 Maas Gallery

20 Cascade in Shadow. Pencil and water-colour.
 Collection: Lord Clwyd

21 Photograph of Samuel Palmer, 1863.
 Author's collection

22 Wooded Landscape with Stream. Water-colour.
 Private collection

23 The Brothers under the Vine. Water-colour.
 Victoria and Albert Museum

24 The Eastern Gate. Sepia wash.
 Victoria and Albert Museum

AUTHOR'S NOTE

IN WRITING this book on Samuel Palmer I have laid more emphasis on the work of his middle and later years than the fashionable estimate of it may seem to warrant. While not denying the unique achievement of his Shoreham days, I feel that many of the things that followed—the studies for some of the etchings, for instance, done towards the end of his life —combine the poetic vision of the Shoreham period with a breadth and freedom of style acquired by years of professional experience. The difficulties and hardships of Palmer's later life—the sheer necessity of earning money—made the Shoreham ideal an impossible luxury; and in his middle years, in the search for the elusive formula of popular success, he resorted to an endless series of experiments and explorations which developed his powers of naturalistic painting and gave him an added mastery of the bold and rapid sketch. That much of his exhibition work at this time was tame and overlaboured is obvious enough, but behind the conventional, bread-and-butter painter there was also the artist who worked to please himself, who filled innumerable portfolios with drawings spontaneously done and distinguished by qualities of poetic feeling that were essentially his own.

It is unfortunate for Palmer's reputation that in many cases the exhibition drawings have survived, whereas a great mass of his 'personal' drawings and designs—'blots', as he sometimes chose to call them—have been lost or destroyed. For this destruction the artist's son, A. H. Palmer, was in a large measure responsible, even to the extent of burning Shoreham sketchbooks. It seems incredible today that someone as devoted to his father's memory as A. H. Palmer was should have thought himself justified in destroying the very things that his father valued most.

In a letter to F. L. Griggs, A. H. Palmer explains what prompted this act of wholesale destruction before he emigrated to Canada in 1910: 'Sooner than that multitude of slight sketches, blots, designs, etc., which my father valued so much . . . should be scattered to the winds, I burnt them, and so much more before we sailed, that the fire lasted for days.'

Of Palmer's many misfortunes, this vast, sacrificial bonfire was surely not the least. Yet if we condemn A. H. Palmer for consigning to the flames such a mass of valuable material, we must recognize, too, how much, in homage to his father's memory, he recorded and preserved. Almost all our knowledge of Palmer comes from *The Life and Letters of Samuel Palmer* written by his son and published in 1892 as an amplified and corrected version of an earlier memoir. Written partly as a defence of his father against the denigration of his mind and character by members of the Linnel family, it tends to leave out or gloss over many things which might have lent themselves to uncharitable interpretation. For this reason Palmer is often made to appear, especially in his later years, as a more conventional figure than he really was. Yet for all this, the *Life and Letters* is a fascinating record of the artist and his times, and I have found the temptation to quote copiously from it irresistible.

'The artist must ignore distinctions between "recognized" or "unrecognized" conventions of form, the transitory knowledge and demands of his particular age. He must watch his own inner life and hearken to the demands of internal necessity. Then he may safely employ means sanctioned or forbidden by his contemporaries. This is the only way to express the mystical necessity.'

'. . . A picture painted in yellow radiates spiritual warmth . . .'

<div align="right">Kandinsky
'Über das Geistige in der Kunst'</div>

CHRONOLOGY

1805 Samuel Palmer born on January 27th, at Surrey Square, Walworth.

1817 In May sent to Merchant Taylors' School, but leaves in the autumn or winter of the same year. Death of his mother.

1818 Studies art under William Wate.

1819 Visits Kent, Bedfordshire, Surrey, Buckinghamshire.

1820 Sells at the British Institution his first exhibited picture, 'Landscape Composition', one of three works exhibited by him. At the Royal Academy this year three works by Palmer hung.

1822 Meets John Linnell, who introduces him to John Varley and William Mulready. Makes figure studies at the British Museum on Linnell's advice.

1824 Meets William Blake. Visits Shoreham for the first time.

1826 Meets Edward Calvert at the Royal Academy. Goes to live at Shoreham, Kent. Works on landscapes and Biblical subjects.

1827 Takes up permanent residence at Shoreham and is joined by his father and his old nurse Mary Ward. Later the family move to 'Waterhouse'. Death of Blake.

1832 In the autumn visits Devon and Cornwall for the first time.

1833 Settles at 4 Grove Street, Lisson Grove, London; but makes periodic visits to Shoreham.

1835 Second visit to Devonshire. Also visits North Wales with Henry Walter. Stays for a while at Tintern on the way home.

1836 Second journey to Wales.

1837 Visits Wales. Marries Hannah, eldest child of John Linnell, September 30th. Two weeks later begins journey to Italy. Visits, among other places, on his 'wedding trip' Paris, Lausanne, Lake Maggiore, Milan, Palma, Bologna, Florence, Rome, Velletri, Terracina, Gaeta, Formia, Naples, Pompeii, Corpo di Cava, Pozzuoli, Tivoli, Subiaco, Papignio, Turin.

1839 Returns from Italy in November of this year.

1841 In September spends some time at Lady Stephen's in Dorsetshire, teaching and painting. (A. H. Palmer gives 1844 as the date for this, but it is almost certainly incorrect. Palmer was at Guildford in September 1844).

1842 Palmer's eldest child, Thomas More, born January 27th. Stays at Thatcham in Berkshire with his family from August to October.

1843 Visits North Wales. Elected an Associate of the Royal Society of Painters in Water Colours.

1844 Palmer's daughter, Mary Elizabeth, born. Visits Guildford and North Wales.

1845 Visits Margate, May to October. Also stays for a month at Princes Risborough, Buckinghamshire.

1847 Death of Palmer's daughter, December 15th.

1848 Visits Devon and Cornwall in July. Paints directly from nature. Death of Palmer's father. Moves from Lisson Grove to 1A Victoria Road, Kensington.

1849 In the summer takes his family to stay at Red Hill, Surrey.

1850 Elected member of the Etching Club. Visits Devon.

1851 Moves from Victoria Road to No. 6 Douro Place, Kensington. Visits North Wales.

1853 Birth of Palmer's second son, Alfred Herbert.

1854 Elected full member of the Society of Painters in Water Colours.

1858 Visits Margate in July.

1859 Visits Hastings.

1861 Illness of Palmer's son, More. In the spring Palmer takes lodgings for his family at 'High Ashes' Farm, near Dorking. Death of More, July 11th. Palmer leaves Kensington, and takes lodgings for a time on Red Hill Common. Later rents a cottage in Reigate.

1862 Moves to 'Furze Hill House', near Red Hill.

1871 Visits Wales.

1872 Visits Margate to make designs for Virgil's 'Eclogues'.

1874 Visits Margate and North Wales.

1875 Visits Cornwall.

1881 Death of Palmer, May 24th.

FOREWORD

When I look back on the Victorians I knew as a child, I mean those truly representative Victorians who survived for me in the persons of great-uncles and aunts and their venerable friends, I am always impressed by their robust self-assurance and their unfailing optimism. When they talked of progress they really believed in it and they possessed, it seems to me, a boundless confidence in everything pertaining to their age, its teachers, its artists, its writers and its prophets. True, a great-aunt of mine used to complain in her later years that Ruskin had spoilt her artistic style by his insistence on the minutely detailed painting of flowers and foliage, but had she neglected his advice and painted them in a broader and more impressionistic way, would the Christmas cards she produced for Messrs Raphael Tuck have proved as popular; or the finely stippled water-colours of flowers which were regularly hung 'on the line' at the Academy have been so warmly admired? I suspect they wouldn't and I suspect, too, that she would have been politely told that she couldn't paint. It would have needed a great deal more artistic genius than my aunt possessed to have successfully defied the rigid conventions of her days. Yet in another way she did defy them and without a qualm threw Victorian conventions to the winds. For some reason that my family never fathomed she suddenly decided never to touch a brush again, to abandon the prim domesticity of a house in Clapham and lead the life of a hermit in the remotest woods of the Wye Valley. It was a stunning decision which the rest of the family tried to explain away by the supposition of an unhappy love affair. There was, I'm convinced, nothing of the kind. Like Ruskin, like Samuel Palmer, like Thoreau, my aunt sought a refuge from the inhibiting pressures of urban life. Though the machine age as we know it now was still a long way off, the signs of its approach were plain to read. For Ruskin the omens were grimly manifest in the proliferation of railways and the spread of the machine; for Palmer in the hordes of shoddy villas that were rapidly blistering the Surrey hills; for my aunt in the disappearance of the tadpole-swarming puddles that used to be for her such a delightful feature of the Clapham roads.

With Ruskin and Palmer it was a case if temperaments so deeply rooted in the traditional world that no adjustment to the new age was possible. Palmer detested its materialism and was contemptuous of its scientific achievements. What mattered supremely for him was something not of the material world at all—'Not the pot and kettle philosophy of The Useful Knowledge Society, beginning in steam-engines and ending in money and smoke, but visionary and ideal. For money and beef are not, as people imagine, the solid things of the mind. . . .'

In an age that prized material success above all else Palmer was clearly out of place. For him the ill-starred pilgrimage from the visionary world of Shoreham to the villadom of Red Hill was an ordeal of a tortured sensibility. In the end, in self-defence, he shut his eyes to the sight of the villas and the railway lines, and withdrew completely into his own private world behind the whitewashed windows of his little study at 'Furze Hill House', near Reigate.

Such a withdrawal may strike us now as neurotic in the extreme. But it should be remembered that for Palmer the old pastoral tradition meant even more than it meant for Ruskin.

Not only did it inspire his art, it virtually shaped it, moulding his mind and sensibility by the subtle magic of its rhythms. The idyllic world of Shoreham into which he has strayed almost by accident was destined, both in its real and in its idealized form, to haunt him all his days. Had he been actually born into it instead of discovering it in his most impressionable years, it might have affected him less profoundly; but coming to it as he did, with Blake's influence like a ferment in his mind, this little corner of Kent took on for him the character of an earthly paradise.

But enchantment has this disadvantage: it seldom lasts, especially in the modern world. And Palmer and Ruskin, though they may seem remote figures to us now, were in fact sufficiently near our time to see the old order being seept away by the first crude onrush of industrialism. And they were horrified at the disruption and ugliness it brought. Hating the new world of smoke and steam-engines, Ruskin sought a refuge in a pure communion with the Alpine snows and among the glowing splendours of Venetian art. But ultimately, even in Venice, there was no escape. A steam-boat appeared on the once-quiet canals, plauging Ruskin's ears with the rattle of its crane and the howl of its hooter. The nineteenth century, which became for him the century of plague wind and storm cloud, was irrevocably committed to the gospel of the machine.

Though we admire and perhaps at times secretly envy the Victorians for their energy and confidence, it is the misfits, the rebels and the 'escapists' who are for us the sympathetic figures. They alone seem to speak with something of a modern voice and in understanding them we can get, if we are honest with ourselves, a clearer realization of our own predicament. If Palmer went too far in his distrust of progress, as, for instance, in his antipathy to gas and railroads, it would be a mistake to dismiss all his views as those of an eccentric reactionary. Behind his prejudice was the conviction that science and materialism could offer no adequate substitute for the spiritual experience. 'If so-called science bids us give up our faith, surely we have a right to ask for something better in exchange!', he exclaims. And when he speaks of the 'illiterate eyes of a senior wrangler' he gives a cogent reminder that a knowledge of science and mathematics does not constitute education in the fullest sense. For Palmer education was first and foremost a training in sensibility and perception. Like Blake, he refused to regard the intellect as the paramount faculty and believed that the supreme moments of illumination belonged to the intuitive senses. But in one respect he differed from Blake: his art depended on his response to nature, and in particular those pastoral forms of nature where the immemorial ritual of husbandry evoked for him a vision of a golden age. For Blake, on the other hand, nature was unnecessary,—one might almost say a bore. Born and bred a townsman, he found it as easy to conjure up visions of prophets and angels among the back streets of London as in surroundings which other men might have considered more inspiring. Palmer, who shared so much with Blake, was in temperament less adaptable. Without nature he was altogether lost, and in his middle years when the drudge of teaching exiled him among the fogs and smells of Victorian London, he was haunted by a sense of deprivation, a feeling that divorced from nature he was like a man vainly groping in a darkened room. In the notebooks and letters of this period he expresses a desperate longing to escape. A week or two in the country, he believes, will restore his vision and give new force and meaning to his art. Meanwhile, like a languishing prisoner, he can only crane his neck from an attic window in the hope of getting a glimpse of a sunset through the London smoke.

Yet what eludes him is not merely nature as a source of subject-matter; it is nature as the sustaining impulse of the inner life. To the modern analytical mind that sees nature as nothng more than a series of inanimate objects, this philosophy of Palmer's may seem incomprehensible. But as pious men of the Middle Ages regarded the cloister as a kind of frontier-post between the earthly and the spiritual life, so for Palmer it was nature and the aesthetic experience that provided, so to speak, the communicating link between the material and the visionary worlds. Yet for all this it should be remembered that Palmer's religion was essentially orthodox. The Christianity of the Middle Ages would have been in doctrine and ritual wholly acceptable to him. Other Victorians may have flirted with medievalism as a fashionable diversion, but in Palmer's case it was something genuine and innate. In this sense he was, if ever there was one, a man born out of his time. In the monastic seclusion of his early Shoreham days he had had his visions and his spiritual intimations and he never questioned their validity. It is hardly surprising, then, that he detested modern rationalism for its tendency to belittle and explain away. And equally he detested the tangible expression of that creed, the new industrial age which, in its obsession with materialism, cared neither for the vision nor the inner voice.

In writing here of Palmer, I have been frequently reminded of that Victorian great-aunt of mine whom I have already mentioned. In her painting days she was Palmer's contemporary, and it was from her that I first heard his name, though I was too young then to know anything about him. Living her solitary but blissfully happy life among the woods, she seemed to have put art entirely out of her mind and her references to it were extremely rare. In fact, I can only recall three occasions on which the subject was mentioned. I remember once when she was shown one of her water-colour drawings of white chrysanthemums, done many years earlier, she expressed surprise and disappointment at finding that the delicate carmine tones she had used for tinting the inner parts of the petals had faded to the coldest blue. I remember, too, her criticism of Ruskin and his theories; and lastly the one brief reference to Palmer. She admired, she said, the natural way in which he had introduced rabbits into one of his landscapes.[1] She herself was very fond of rabbits and couldn't resist putting them into the occasional landscapes she painted. Hence her admiration. I don't suppose she had any great knowledge of Palmer's work, though as persons they had a number of things in common. Both, for instance, were deeply religious, though my aunt's religion was, in the matter of science, a good deal more accommodating than Palmer's. She used to quote the words from St Matthew, 'There is nothing covered, that shall not be revealed; and hid, that shall not be known', as proof that religion and science were not antagonistic, but rather complementary instruments in an unceasing process of revelation. What she fully shared with Palmer was a horror of urban respectability and the restrictions it imposed. I can never read Palmer's descriptions of the chivying activities of housemaids which became for him such a bugbear

[1] I have never succeeded in tracing this work. But it seems that L. R. Valpy, Palmer's patron in later years, possessed a sketch by the artist in which the place for a possible rabbit had been defined. Of this sketch Palmer writes: 'In your North Devon cornfield, there is a bit of white left as a good place for a rabbit, in case of making a picture from it. Now, if I were to put in a good rabbit, it would unfinish the corn; and work upon the corn would *ruin* the distance, which is the point of the case. For sketches and pictures are wholly different things. . . .'
There is also in the Ashmolean Museum, Oxford, a sepia landscape drawing dated 1825 which shows a rabbit on a woodland path.

in his Reigate years, without thinking of my aunt suffering the same martyrdom by broom and duster in the prim decorum of her parents' home at Clapham. No wonder that when the time came she sold all the carefully polished furniture to the rag-and-bone men and fled for freedom to the wilds.

Yet what she and so many other sensitive Victorians sought was something more than freedom. They were concerned, it seems to me, with a much deeper problem, though they lacked the psychological knowledge to define it. In my own mind I compare them sometimes with those canary birds that are lowered down wells and mines to test the oxygen content of the air. What they detected was, I think, the beginning of a long and gradual process; the first lapsing away from the old levels of instinctive consciousness, the first withdrawal of the psyche into its modern state of isolation. Paradoxically, it was the very pressure of human contact which industralism brought and the closer integration it imposed which intensified this sense of isolation and made them vaguely aware that the old sense of an Eden-created unity between man and nature was passing from their lives.

Palmer behind his whitewashed windows at 'Furze Hill' and my aunt living in her bracken-roofed hut alone in the depths of the woods, without clocks or newspapers, never doubted the reality of that unity. To think of nature as the product of a blind process of evolution was to deny the whole basis of their philosophy. For them nature was the key to the invisible gates, and the world it opened was infinitely more rewarding than the world of genteel villas, city offices and bourgeois affluence. As a boy I used to wonder how it was that my aunt, who never saw a soul for weeks on end, could display when one met her all the gaiety and brilliance of someone who had spent their time in the most stimulating company. It was as if nature poured into her a continual stream of vital energy, and the trees and rocks on that remote hillside had become for her communicating presences.

Palmer would have found nothing strange in that. What was incomprehensible to him was the scepticism that could conceive no possibility outside the narrow limits of accepted fact. If one thinks of him as a mystic, it is not in the sense of someone versed in the esoteric and the arcane, but as a visionary whose qualities of spiritual insight made the theories of science seem to him little more than a perverse misreading of the truth. Like Plato, he believed in an ideal essence beyond the visible world, and like the mystics of almost every age and race, he believed that there were certain states of consciousness, moments of receptive stillness in the mind when new horizons were revealed and the old limits of perception dropped away. 'Blessed thoughts and visions haunt the stillness and twilight of the soul', he once wrote, 'and one of the great arts of life is the manufacturing of this stillness.' That is typically Palmer. Unlike Constable, whose art is so much a thing of dew and sunlight, Palmer had a predilection for the shadowy nuances of evening. In his work twilight and nightfall are recurring themes, especially in his Shoreham days, and the great moons and stars that brood above his landscapes are more than picturesque accessories; they are the key symbols of his art. He might indeed have shared D. H. Lawrence's belief that human consciousness was a system of polarity, of two balancing centres, the day-self, and the night-self, representing the conscious and the sub-conscious levels of the psyche. With Palmer it was the night-self (to use Lawrence's terminology), the self that moved in the mysterious world of dream and vision, which gives so much of his work its curious trance-like quality. When he speaks of the thoughts and visions that haunt the stillness and twilight of the soul he refers to those symbols and images in the

subconscious which at moments assumed for him all the force and immediacy of actual experience.

Clearly then, Palmer was not a normal person in the accepted sense, any more than Blake had been in his day. But Blake, though sensitive to men's opinions, was a freer agent than Palmer was and his qualities of pugnacious independence effectively insulated him from the pressures of conformity. When critics called him mad he might be stung to an angry retort, but he remained staunchly faithful to his vision. For personal and social reasons Palmer was more vulnerable. It was one of the misfortunes of his life that his father-in-law, John Linnell, the painter, once a friend and admirer of Blake, grew to dislike him and regarded him as a person of unbalanced mind. Through Linnell, Palmer's marriage was virtually wrecked, and in an attempt to counter Linnell's accusations of mental instability, Palmer tended, after his marriage, to conventionalize his art and to prune out those qualities of strangeness which might seem to justify his father-in-law's unflattering view of him. Though he liked to call himself 'a Christian bulldog', his sense of worldly failure made him ineffectual in holding his own against a father-in-law whose belligerent temperament grew more despotic as the passing years loaded him with the rewards and prestige of professional success. And Linnell himself, quarrelsome, egotistical and fanatically intolerant, a man whose private brand of Christianity did not deter him from forming what amounted to an incestuous relationship with his daughter, Palmer's wife, never questioned, it seems, his right to judge.

Writing of his father's final move to 'Furze Hill House', which was virtually on Linnell's doorstep, A. H. Palmer says: 'Of all the blunders in my father's career, none was greater, so far as he himself was concerned, than the choice of a new home so close to the famous despot and almost incredibly unpacific painter of peaceful and beautiful landscape.'

Thus brought completely within the Linnell orbit, the Palmer family, like the members of the Linnell's own household, became the helpless captives of that despotic will.

For Palmer it was the end of his personal freedom. Exiled in the villa-world he despised and detested, he complied with conformity by keeping the number of servants that his father-in-law prescribed for him and even on occasions by transforming his own art into something very near an imitation of Linnell's. This change of style was not servile flattery, nor was it, as some members of the Linnell family later alleged, downright plagiarism. In his dealings with Linnell, Palmer had learned the diplomacy of *force majeure*; and in his art, as in his personal life, there were those crises of opinion when the views and theories of his father-in-law had to be deferred to by a policy of self-effacement. In return Palmer gained some measure of domestic peace and ultimately, through the generous settlement that Linnell made to his daughter, a sense of financial security he had never previously enjoyed.

And in that little study at 'Furze Hill House', with its makeshift furniture and its white-washed windows vainly protesting against the encroachment of the brick-and-mortar tide, Palmer kept alive some remnant of his individuality. It was a refuge where even the all-pervading influence of Linnell scarcely reached and gentility in all its forms was rigorously debarred. Here among the home-made folios crammed with unsold drawings were those golden visions of the Shoreham days to refresh the eye and to provide a touchstone of that poetic and imaginative feeling which was always for Palmer the essential aim in art. Yet these precious early drawings, so prized by the painter and his few discerning friends, must have been for him a poignant reminder of all that happened in the intervening years—the agonizing grief, the

neglect, the professional hardships, the poverty, the shattered hopes, the humiliating surrenders. Remembering Shoreham, he may also have recalled those lines of Dante:

'Nessun maggior dolore,
che ricordarsi del tempo felice
nella miseria.'

Yet if there is no greater pain than to recall a happy time in wretchedness, Palmer bore it with something of that patient faith which had sustained the pious men of Dante's age. A medievalist born out of his time, he believed that uncomprosing standards of conscience and craftsmanship were a moral obligation of the artist's calling, and it was a token of his faith that in an age that had ceased to care about such things he followed the lonely path of his ideal without material reward or even the consoling hope of posthumous recognition.

If Palmer was an alien figure in his own time, he should by every reckoning to be even more so in the present century, which has left the Victorians so far behind in the advancement of scientific materialism. Yet, paradoxically, the opposite is the case. This obscure and forgotten Victorian has become a major influence in contemporary British painting and a key figure in Romantic art. It is a curious metamorphosis, and a reminder perhaps that the world of art and personality has a logic of its own, and that here at least the ultimate arbiter of things may be those unseen forces in which Palmer, the friend and disciple of William Blake, so fervently believed.

ACKNOWLEDGEMENTS

I wish to express my thanks to the private collectors and the Trustees of Public Galleries who have kindly allowed me to reproduce works by Samuel Palmer in their possession. I am also particularly grateful to Mr David Dulley for his enthusiastic help in the matter of Palmer's etchings; and to Mr Edward Malins for generously making available to me material from his own researches.

The Man and His Work

SAMUEL PALMER was born on January 27th, 1805, at Surrey Square, Walworth. His Baptist father, whose unworldliness and lack of practical sense the son had the misfortune to inherit, was then trading as a bookseller—an occupation which the richer and more successful members of the family regarded as a slur upon their name. Young Palmer's formal education consisted of a few months at Merchant Taylors' school. Apparently he failed to adjust himself to the rigours of school life and returned to the Palmer home to pick up what knowledge he could in the family circle. In these early days some taste for drawing showed itself, and Mrs Palmer called in an obscure drawing-master, a Mr Wate, to direct and encourage him.

After Mrs Palmer's death, the father and son moved to No. 10 Broad Street, Bloomsbury, the trade of bookselling being continued there. While in the new home young Palmer's artistic gifts developed rapidly and at the age of fourteen he sold a picture he had exhibited at the British Institution. Between 1819 and 1824 he exhibited seven more landscapes there, as well as several at the Royal Academy. In 1819 he had paid his first visit to the Academy and had been at once deeply impressed with Turner's 'Orange Merchantman'. He recalls that afterwards when 'Mr George Cooke, the engraver, would sometimes drop in on an evening for talk about art, the engravings of the brothers from Turner formed part of the pabulum of my admiration—lunacy I may almost say, before the popular expositors of that wonderful man were born'.

In 1821 Palmer produced what seems to me one of the most impressive examples of naturalistic art he ever did, a water-colour sketch, 'Hailsham, Sussex: storm effect'. It is something unique in Palmer's *oeuvre* and shows the direction his art might have taken if other inclinations had not proved too strong. The bold, broad masses of sea and cloud suggest the work of Cotman, with something of Turner's dash throw in.

In these early years Palmer got valuable advice from William Stothard, who had drawn a portrait of Palmer's mother. Stothard also gave him occasional tickets for lectures at the Royal Academy, where he heard Flaxman lecturing on sculpture. Later he made the acquaintance of John Linnell, a meeting which came about, according to George Richmond, through Linnell's admiration of some small sepia landscape drawings done by Palmer. To Linnell, Palmer owed his introductions to the artists John Varley and William Mulready—and, most important of all, to William Blake.

The effect of these contacts and influences was to turn Palmer's ideas away from the kind of naturalistic painting which the Hailsham sketch represents. What followed now was art of a very different kind, as the pages of an 1824 sketch-book clearly show. It is as though Palmer's whole sensibility has changed, as though he has begun to see again with the imagina-

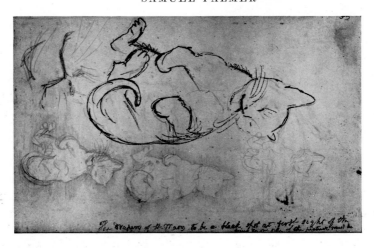

(i) *Study of a Cat. Indian ink, with smaller studies in pencil* (*British Museum*)

tive vision of a child. Why this change of style? The explanation lies in the advice given to him by John Linnell. It seems that Palmer's first meeting with Linnell was in September 1822, a a year after the Hailsham drawing was done, and that about this time Linnell showed him examples of Blake's work. He also told Palmer to study the figure seriously and to look at the art of Albert Dürer. One might almost say that the 1824 sketch-book shows Palmer reeling under the impact of this advice. Yet how extraordinary these drawings are! The influence of Blake and Dürer has produced a style that might be termed primitive expressionism. Some-times the line is tentative and wavy, as though drawn by someone in a trance, and at other times it takes on the kind of brutal power one associates with an artist such as Rouault. They are strange and disturbing drawings, and to anyone unprepared by the experimental anarchies of modern art they might seem little more than crude aberrations. Looking at them, one can understand, without in any sense condoning it, the mistaken loyalty of Palmer's son which made him in later years destroy other sketch-books of this kind lest they gave rise to doubts about his father's sanity.

What these pages show is not derangement, but the ferment and hypersensitivity of young Palmer's mind, a state not uncommon in an artistic youth of nineteen. And the notes that Palmer made in these early years have the same strange quality as the drawings themselves. It is as if there were at times two people here—the artist, and in the background, so to speak, a detached and critical observer who looks over the shoulder of the artist as he works. Thus Palmer, the observer, addresses Palmer the creative self:

'It is now twenty months since you began to draw. Your second trial begins. Make a new experiment. Draw near to Christ, and see what is to be done with Him to back you. Your indolent moments rise up, each as a devil and as a thorn at the quick. . . .'

In a note about possible subject-matter Palmer's religious fervour takes wing in the idea that the 'Glories of Heaven might be tried—hymns sung among the hills of Paradise at even-tide; . . . a martyr, having painted his murder, laughing, or rather smiling at his torments. A family met in Heaven. . . .'

(ii) *Landscape Study with Crescent Moon. Indian ink* (*British Museum*)

In attempting to recapture the primitive vision of the early painters, Palmer turns his back on what he calls 'the flashy and distracted present', and he rejoices that 'it pleased God to send Mr Linnell as a good angel from Heaven to pluck me from the pit of modern art.'

In the sketch-book of 1824 we see him moving towards the kind of primitive, stylized art which he was to develop so impressively in the paintings of the Shoreham landscape which followed two years later. In the pages of this book there appear for the first time those key symbols which reoccur in so much of Palmer's most characteristic work—the brooding moons, the disc-leaved trees, the towers, the reclining figures that seem immobilized in trance, the globular hill forms, the primitive cottages. Here they are still, as it were, exercises in evocation, the first mapping out of the strange imaginative world that was forming itself in Palmer's mind. In 1824, it must be remembered, Palmer had looked at art, but had received virtually no formal artistic training. He had been to the British Museum, as Linnel advised, with the idea of drawing the figure from classical statuary, but had accomplished little. The fact was that his lack of grounding prevented him from taking advantage of what he saw.

27

Linnell's advice in the matter of figure study was sound and practical enough, but his suggestion that Palmer should also look at Dürer was positively inspired. For Dürer, if anybody, was Palmer's man. Though Dürer's work is packed with a symbolism of which the modern world has largely lost the key, it still communicates with haunting power the spiritual intensity of the Gothic world. And the synthesis of simplicity and elaboration which is the essence of Dürer's style helped to clarify for Palmer the nature of his own ideal. Thus, though he had been given little or no formal teaching, it may be said that he received his supreme lesson in art from one of the world's greatest painters and draughtsmen. In the sketch-book of 1824 the influence of Dürer, Lucas van Leyden and other early masters shows itself in the general Gothic feeling and in the wiry economy of line.

Besides telling Palmer to look at Dürer, Linnell rendered him one more outstanding service: he introduced him to William Blake. Palmer's description of this meeting has been quoted many times, but the picture it gives of Blake and Palmer is so vivid and personal that it loses nothing by repetition.

'On Saturday, 9th October, 1824', Palmer writes, 'Mr Linnell called and went with me to Mr Blake. We found him lame in bed, of a scalded foot (or leg). There, not inactive, though sixty-seven years old, but hard-working on a bed covered with books sat he up like one of the Antique patriarchs, or a dying Michael Angelo. Thus and thus was he making in the leaves of a great book (folio) the sublimest designs for his (not superior) Dante. He said he began them with fear and trembling. I said "O! I have enough of fear and trembling." "Then," said he, "you'll do." He designed them (100 I think) during a fortnight's illness in bed! And there, first, with fearfulness (which had been the more, but that his designs from Dante had wound me up to forget myself), did I show him some of my first essays in design; and the sweet encourage-ment he gave me (for Christ blessed little children) did not tend basely to presumption and idleness, but made me work harder and better that afternoon and night. And, after visiting him, the scene recurs to me afterwards in a kind of vision; and in this most false, corrupt, and genteely stupid town my spirit sees his dwelling (the chariot of the sun), as it were an island in the midst of the sea—such a place is it for primitive grandeur, whether in the persons of Mr and Mrs Blake, or in the things hanging on the walls.'

As an artist, of course, Blake is not to be compared with Dürer, but he possessed certain visionary powers, or as we today clumsily term it extra-sensory perception which in Dürer's age would have been readily understood and accepted. Such powers were as much out of place in the rational climate of Blake's time as, say, modern chemical analysis would have been in the fifteenth century. That Blake was something out of the ordinary was instantly recognized by all who knew him. He was, like D. H. Lawrence, whom he in so many other ways resembles, one of those rare persons who seem to touch the very flame of life and who penetrate intuitively the sealed frontiers of consciousness, communicating through their art and personality an enriching sense of otherness. Today we tend to explain such people purely in terms of abnor-mal psychology, much in the same way as many of Blake's contemporaries who failed to understand him flattered their own superiority by dismissing him as a harmless lunatic.[1] Palmer was wiser. When he left Blake's humble quarters that October evening in 1824 he was like a man inspired. That meeting and subsequent contact with Blake were to be the

[1] In one of his last references to Blake, Palmer describes him 'as being of all men whom I ever knew, the most practically sane, steady, frugal and industrious'.

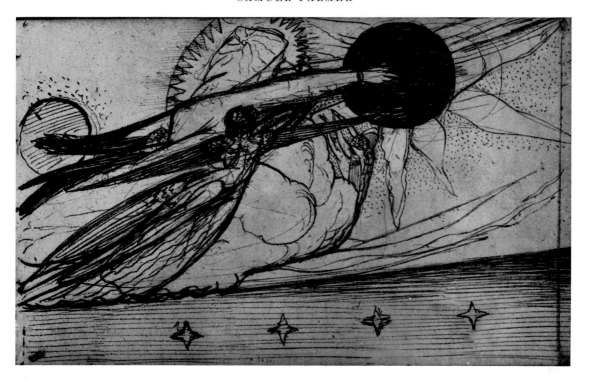

(iii) *God creating the Firmament. Indian ink* (*British Museum*)

polarizing influences in his life, and it was with no affected show of reverence that he after-wards always kissed Blake's bell-handle before venturing to pull it.

'The House of The Interpreter' was the name that Palmer and his friends gave to Blake's modest rooms in Fountain Court. This name, taken from Bunyan's *Pilgrim Progress*, helps us to define the nature of Blake's influence on Palmer. If we call Palmer a disciple of Blake, it is only true in the sense that it was Blake's authority and personal example that helped to bring out in Palmer the powers and inclinations already latent in him. Blake's part was that of spiritual interpreter and guiding genius—the sympathetic visionary through whose eyes Palmer saw his own path more clearly mapped.

When Palmer first visited Blake's rooms in a squalid London back street, that veteran poet and artist, that imaginative genius who talked familiarly with prophets and angels, and whose feeling of personal dignity amounted, it has been said, to a ruling passion, was supporting himself and his wife Kate on the sum of £1 0s. 5d. a week.

In the matter of personal dignity certain members of the Palmer family also had their views, though these were of a less exalted kind than Blake's. For them personal dignity was largely equated with a chill form of respectability and with the leisured life which in their eyes was a condition absolutely essential to the status of a gentleman. They considered that the trade of bookselling in which the elder Palmer was engaged brought discredit on the family and must therefore be stopped. Accordingly, an ultimatum was sent to Palmer's father

to the effect that he must either cease his bookselling or forfeit the allowance which the family made to him. Presumably with reluctance the unworldly bookseller relinquished his literary stock, showing for once sound common sense in preferring a regular income to the hazards of books. Having sold up his stock for the sum total of £133 6s. 0d., he retired to Shoreham, Kent, to lead the kind of gentlemanly existence which his richer and more pretentious relatives insisted on.

Prior to his father's retirement, which in all probability took place in 1827, young Palmer had visited Shoreham a number of times and had lodged there for some months in 1826. Something about the place seems to have developed the mystical tendencies in him, and the notes he wrote there show the almost torturing intensity of his religious feelings. Like Blake, he had in these early years a consciousness of spiritual presences. 'Sometimes for weeks and months together', he writes, 'a kindly serene spirit says to me on waking in the morning the name of some great painter, and distresses me with the fear of coming short at last; and I think it is then that I do most good.'

Among the notes of 1825 Palmer has added a list of subjects taken from the books of *Ruth*, *Daniel* and *Jonah* as material for his art. And with it goes a prayer that his 'visions' of the story of Ruth and Naomi may come to creative fruition. 'Young as I am, I know—I am certain and positive that God answers the prayers of them that believe, and hope in his mercy. I sometimes doubt this through the temptation of the Devil, and while I doubt I am miserable. . . .'

Writing his father's life in the late Victorian period, A. H. Palmer says of these many soul-searching confessions: 'I have quoted them reluctantly; firstly because they were never intended to be seen; and secondly because they show a mental condition which, in many respects, is uninviting. It is a condition full of danger, and neither sufficiently masculine nor sufficiently reticent.'

Yet had they never been quoted, or had they been muffled with the kind of sheepish reticence which Victorian standards required, how much of the essential Palmer would have been lost. It is indeed fortunate for us that he inherited from his father the habit of noting down on paper the things he wished to remember and also of stating in written terms any problem with which he was faced, believing that by this means he could more easily arrive at a solution. As he himself puts it: '*Writing* our difficulties; which writing compels us to think clearly of them, during which effort they will often vanish.'

So we find committed to paper these strange outpourings and communings, these almost case-book records of stress and crisis, by which Palmer seeks, as though through the alleviating power of the confessional, to reorientate his religious and artistic faith.

It was apparently with the idea of designing from the book of *Ruth*, as mentioned in the notes already quoted, that Palmer decided to spend some months at Shoreham. And for health reasons a long stay in the country was considered necessary. In the spring of 1826 he and his friend Arthur Tatham, a sculptor and fellow disciple of William Blake, took up residence in Shoreham. Characteristically, he begins his sojourn there with a prayer inscribed 'On going to Shoreham, Kent, to design for *Ruth*'.

The cash accounts recorded by Palmer during this stay suggest a régime of monastic austerity. Meat was a luxury eaten only occasionally, and the main diet consisted of milk, eggs, bread and butter. Besides the cost of food and lodging, there were modest disbursements on

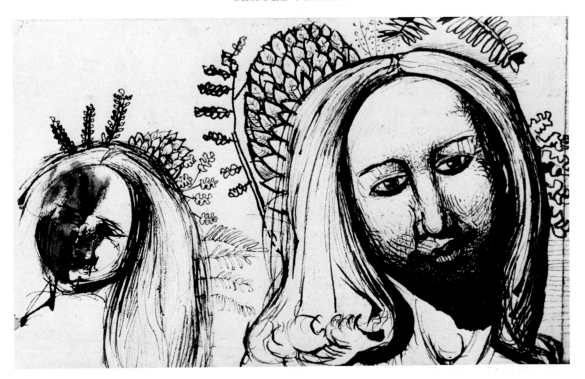

(iv) *Two Studies of a Girl's Head. Indian ink* (*British Museum*)

such things as books, gold paper, pencils, postage and ivory tablets. For Palmer, as for the mystics of other centuries, the effect of such monasticism was to intensify the inner life and to reinforce more vividly the evidence of things unseen. Good and evil became for him per-vading presences that could at any time inspire or thwart the artist's vision. 'At Shoreham, Kent, August 30, 1826. God worked in great love with my spirit last night, giving me a founded hope that I might finish my *Naomi before Bethlehem*, and (to me) in a short time . . . That night, when I hoped and sighed to complete the above subject well (it will be my maiden finished figure drawing), I hoped only in God, and determined next morning to attempt working on it in God's strength . . . now I go out to draw some hops that their fruitful sentiment may be infused into my figures . . . August 31. We do or think nothing good but it has its reward. I worked with but little faith on my *Naomi before Bethlehem* this morning and succeeded just in proportion. After dinner I was helped against the enemy so that I thought one good thought. I immediately drew on my cartoon much quicker and better . . . Satan tries violently to make me leave reading the Bible and praying . . . O artful enemy, to keep me, who devote myself entirely to poetic things, from the best of books and the finest, perhaps, of all poetry . . . I will endeavour, God helping, to begin the day by dwelling on some short piece of scripture, and praying for the Holy Ghost thro' the day to inspire my art. Now, in the twilight, let Him come that at eventide it may be light . . . The last 4 or 5 mornings I thank God that He has mercifully taken off the load of horror which was wont so cruelly to scare my spirits on awaking. . . . Wednesday. Read scripture. In morning, ill and

incapable, in afternoon really dreadful gloom; towards evening the dawn of some beautiful imaginations, and then some of those strong thoughts given that push the mind [to] a great progress at once, and strengthen it, and bank it in on the right road to TRUTH. I had believed and prayed as much or more than my wretched usual, and was near saying "what matter my faith and prayer?" for all that day I could do nothing; but at evening-time it was light; and at night, such blessed help and inspiration!. . . . Thursday. Rose without much horror. This day, I believe, I took out my *Artist's Home*, heaving through a change in my visions got displeased with it; but I saw that in it which resolved me to finish it. Began this day scripture. Friday. So inspired in the morning that I worked on the *Naomi before Bethlehem*, which had caused me just before such dreadful suffering, as confidently and certainly as ever did M. Angelo I believe.'

Cut off from the world of professional art, Palmer fought his strange spiritual battles on the peaceful banks of the river Darent. It was an exile that made him an artist, and at Shoreham, in the 'valley of vision', as he called it, he followed with astonishing power and originality the path of art that Blake had opened to him. Palmer's friend Edward Calvert said of Shoreham: 'It looked as if the Devil had not yet found it out'; and for two such unworldly beings as Palmer and his father it endeared itself as a Kentish embodiment of an Arcadian dream.

When the elder Palmer finally gave up his attempts at business and migrated to Shoreham he brought with him his cherished library, and also as a member of his household, Mary Ward, Palmer's old nurse. Soon after the initial move, the Palmers were established in 'Waterhouse', a mellow red-brick house built in 1704 and standing virtually unchanged today. It was a paradisaical retreat, with an old walled garden sloping to the river Darent and a bridge that spanned the river almost within the garden walls. Near at hand was the village of Shoreham, full of what Palmer called 'pastoral essence', and surrounded by one of the richest tracts of country in all England. Here among the hop-fields, the orchards, the ancient farmsteads with their oast-houses and granaries, Palmer found an immemorial way of life, with forms of husbandry that must have evoked for him visions of the Virgilian age. Dürer—Blake—Shoreham: the door of his art was suddenly opened as by the magic of a master-key. The forms he had noted down in the sketch-book of 1824 were the archetypes of what he saw and apprehended now at a deeper level of consciousness. The period of his greatest art had indeed begun.

With his father as controller of the household, the austere régime which Palmer had imposed upon himself was partly relaxed. One luxury made its welcome appearance—tea. But there were conforts of a more intrinsic kind. The arrival of Palmer's father at Shoreham meant a plentiful supply of books and music, as well as greater opportunities for social life. A group of Palmer's friends who nicknamed themselves 'The Ancients' in token of their preference for the life and customs of the past, were frequent visitors to 'Waterhouse'. These friends, Edward Calvert, F. O. Finch, John Giles, George Richmond and Henry Walter, were all artists, with the exception of John Giles, who was a stockbroker, but a man who fully shared the romantic ideals of Palmer and the rest. Of 'The Ancients' Calvert wrote: 'We were brothers in art, brothers in love, and brothers in that for which love and art subsist—the Ideal—the Kingdom within.'

Sometimes John Linnell would abandon his frenzied industry in Bayswater to pay a recu-

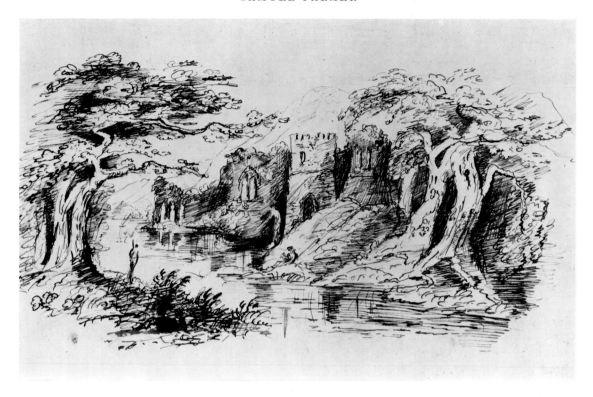

(v) *Ruins on a River-bank. Pen and sepia*

perative visit to the quieter world of Shoreham. A. H. Palmer describes him 'as working under forced draught', and sustaining himself with 'much good wine, and home-brewed ale, and by oxygen gas, Priestly's discovery, then sold in bottles by druggists under the name of ''Vital Air''.' Yet, in spite of these restoratives, sheer physical exhaustion sometimes got the better of him, and on one occasion when visiting Shoreham he was taken from the coach in a state of collapse by Palmer and Richmond, who conveyed him in a wheelbarrow to 'Waterhouse'. Afterwards the wheelbarrow was used as a kind of invalid-chair to carry him about.

In a letter to Palmer written in the summer of 1826, Linnell pays tribute to the revivifying effects of Shoreham. 'I have found so much benefit from my short visit to your valley, and the very agreeable way in which we spent the time, that I shall be under the necessity of seeing you again very soon at Shoreham. I dream of being there every night almost, and when I wake it is sometime before I recollect that I am in Bayswater . . . How I shall recompense you for your kindness I know not, but I am so set upon the thing that I am induced to run the risk of imposing upon it to the utmost, until time affords me some opportunity of testifying my sense of your hospitality, for though I have been at many places on visits, I never was anywhere so much at liberty . . .'

At 'Waterhouse' there were no social restrictions; indeed, personal freedom carried some-times to the point of eccentricity was very much the order of the day. Palmer with his flowing beard and his heel-length cloak must have seemed to the villagers an apparition from the

Druid age. 'Extollagers' was the name coined by the villagers for Palmer and his friends, and if one thinks of it as vaguely compounded of eccentric and astrologer (in the occult sense) one has, I think, a fair notion of the kind of impression they created. Even the folding stools used by them on their sketching expeditions were regarded by the simple Shoreham folk as being in some way connected with the practice of black magic. And the strange nocturnal habits of the 'Ancients' must have given rise to other equally wild theories and conjectures.

Quoting some words of his father, A. H. Palmer tells us 'that "summer nights were spent under the open sky to watch the Northern glimmer and the flushes of early dawn"—that Locke's *Macbeth* music was "sung by night in hollow clefts and deserted chalk pits", and that sometimes the climax of a tragedy was roughly improvised in a certain Black Lane, a dark, lonely place, and the scene of a half-forgotten murder.

'The party often walked by night to distant villages, or carefully chosen spots far away among the hills, whence they could see the sunrise over the flower of Kentish scenery. They were also especially fond of those effects that gather in the sky with great summer tempests, and at the first mutter of approaching thunder, whether by day or night, they hurried out and revelled in the thickest of the storm.'

No wonder the villagers stared! But as time went on they grew to accept the 'Ancients', and the old barriers of suspicion disappeared. For Palmer these contacts with the Shoreham community were important in the sense that they supplied what one imght call the earth roots of his art and so saved it from drifting too far into the rarified atmosphere of the imaginative and the ideal. In personal terms they were the equivalent of his direct studies from nature and his careful records of what he called 'real landscape'. Without these studies and without his actual contact with ploughmen, shepherds and the like his paintings of the Shoreham scene might have lacked that earthy and sinewy strength which adds so much to the richness of his art.

To understand what Shoreham meant to Palmer, it is worth quoting the description of it written years later by his son, but a description that is almost certainly a recollected summary of much that Palmer himself must have said. The concluding passage about the diminished splendour of latter-day moons is surely Palmer and no one else.

'London is only twenty miles away; but years ago, a distance now disposed of by a few puffs of steam kept back that foul tide that has crept little by little over so much of Kent and Surrey. No unsavoury crowds defiled the sweet air with their ribaldry, and no shrieking engine startled the hares from their twilight supper, or the herons from their patient watch over the shallows. Everything connected with the little village in those happy times seemed wrapped about with a sentiment of cosy, quiet antiquity, full of associations that carried you far back into the pastoral life of merry England, years ago . . .

'Spring clothed the innumerable orchards with clotted blossom, and Autumn never failed to fulfil this fair promise by lavishing the fruits in such profusion that the very leaves seemed in hiding, and the boughs were bent lower and lower till their treasure rested on the grass. Rich too were the harvests that the kindly soil gave to her sunburnt children, whose dress was beautiful and whose very implement was archaic. No grudging machinery clawed away the gleaner's perquisite, but they toiled on till the harvest-moon gilded their faces and the hungry owl gave them shrill warning of his supper-time. . . .

'The moon herself bore little resemblance to the pallid, small reality we see above us nowadays. She seemed to blush and bend herself towards men (as when she stooped to kiss Endy-

(vi) *Landscape with figure embracing a tree trunk. Pencil and wash*

mion in olden time) casting a warm, romantic glow over the landscape that slept at her feet.'

Though accommodation at 'Waterhouse' was limited, there was also Palmer's cottage (nicknamed 'Rat Alley') as an additional meeting-place for the 'Ancients' and their friends. Sometimes the great Blake himself paid a visit to Shoreham, and one occasion made the journey from Charing Cross in a covered stage wagon in company with Mr and Mrs Calvert, Palmer also being with them.[1] On this occasion the Calverts were the honoured guests and were allotted the largest room in Palmer's house; Blake had lodgings provided for him by a neighbour and Palmer found quarters for himself in the village bakery.

This visit by Blake was memorable for a striking demonstration of his clairvoyant powers. According to the evidence of Edward Calvert, Palmer had taken the coach to London, leaving Blake and the others at 'Waterhouse'. About an hour after Palmer's departure Blake, who was sitting at the kitchen table, put his finger to his head and announced: 'Palmer is coming; he is walking up the road.'

Someone then reminded Blake that Palmer had gone to London and had been seen off by them on the coach. But Blake persisted: 'He is coming through the wicket.' Blake proved

[1] A. H. Palmer suggests that Mrs Blake may have been there, too.

35

right. The London coach had broken down and Palmer had returned to the village on foot.

The mention of Calvert's name in connection with this incident is a reminder of the special place he occupies among the followers of William Blake. Apart from Palmer himself, he is the most interesting and in a sense the most enigmatic member of the group. And in Palmer's life he was a sustaining influence in its darkest moments of bereavement and despair.

Born in 1799 at Appledore, North Devon, Edward Calvert was a descendant of Sir George Calvert, who had founded the colony of Maryland in America. It was perhaps an inherited propensity for adventure that made young Calvert decide to go to sea. At the age of fifteen he became a midshipman in the Navy, and in 1816 took part in the naval bombardment of Algiers. In this eight-hour action he himself was slightly wounded and his closest friend was shot down by a cannon-ball at his side. The loss of his friend unsettled Calvert and turned his mind to the consolations of art. In 1820 he left the Navy, but not without an experience that was later to have a profound influence on his mind and art—a voyage to Greece with the Mediterranean squadron.

A good seaman with every prospect of promotion, Calvert abandoned his naval career with a good deal of hesitation and in the face of discouragement from his family. After taking lessons in art at Plymouth, he came to London in 1824 and was immediately influenced by Palmer's sketches and the work of Blake. Later, his house at Brixton became a meeting-place for the 'Ancients', though not in quite the same sense as 'Waterhouse'. Because he was older than Palmer and had received more formal training in art than Palmer ever had, it was for a long time assumed that Calvert was a formative influence in Palmer's style. In point of fact, the reverse is the case. Calvert learnt from Palmer, and the finest of his lithographs and etchings—those that seem most Palmeresque—were done from 1827 to 1829, when Palmer, as the evidence of the 1824 sketch-book clearly shows, had olreapy achieved an individual style.

Yet whatever Calvert learnt from Blake and Palmer, it in no sense detracts from his own achievements or lessens in any way those wonderful qualities of imagination and dexterity which are so impressively revealed in his early engravings.[1] Indeed, so rich is the talent and the promise that it becomes all the harder to explain the subsequent decline in Calvert's art. How was it, one can only ask, that the creator of such things as 'The Bride' and 'The Cyder Feast' (which, in poetic richness,' Palmer declares, 'beats anything I know, ancient and modern'), how was it that such a superb designer could in a few years degenerate into a purveyor of nebulous sentiment? It may be that Calvert's drift towards paganism, which Palmer so much deplored, weakened the religious basis of his vision; that his art was, in fact, only a kind of moon art that depended for its life on the sustaining power of Blake's resplendent sun. For a year or so after Blake's death Calvert's vision survived, then dwindled away in the gossamer prettiness of Arcadian sentiment. It was a sad falling off, and it indicates perhaps the extent to which Blake had been in his lifetime the controlling influence on Calvert's mind.

When I speak of Blake in this context I am thinking not so much of Blake the artist as of Blake the man. Indeed, it seems to me that Blake as an individual, as a powerful and illuminating personality, was probably greater than either Blake the artist or Blake the poet. What

[1] It was Calvert who one day, when walking with Palmer, suddenly stopped and said 'Light is orange'—words which Palmer never forgot.

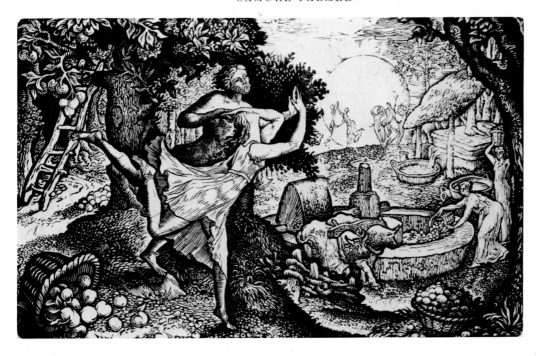

(vii) *The Cyder Feast by Edward Calvert. Wood-engraving*

he did for Palmer and Calvert was to infuse into them a revelationary sense of their own capacity and to stimulate by his remarkable personal powers their faculties of insight and imagination. It is a gift possessed in varying degrees by all great prophets and teachers. The test for the disciples comes when the living presence disappears and only the legacy remains. It was fortunate for Palmer that he had absorbed enough from Blake to make him, so to speak, Blake-minded all his life. For Calvert, on the other hand, the loss of Blake the man seems to have emptied his mind of all those aims and ideals which Blake had stood for.

After Blake's death in 1827, the 'Ancients' continued to meet and correspond in much the same way as they had always done. About this time Palmer and George Richmond discussed a plan for visiting Italy, but were handicapped by lack of funds. Both men, however, were confident of earning money enough in the immediate future. Palmer, in fact, was positively optimistic about his prospects, though loftily determined not to debase his artistic ideals for the sake of monetary gain.

'By God's help,' he writes to Richmond in 1828, 'I will not sell His precious gift of art for money; no nor for fame neither . . . Mr Linnell tells me that by making studies of the Shoreham scenery I could get a thousand a year directly. Tho' I am making studies for Mr Linnell, I will, God help me, never be a naturalist[1] by profession.'

A thousand a year from Shoreham studies was a fantastic estimate, and one can only suppose that on this occasion the practical and business-like Linnell had allowed his judgement to be swayed by the heady effects of home-brewed ale or 'Vital Air'.

[1] He means here a copyist of nature in the facile, pot-boiling sense.

Richmond was on surer ground when he weighed his prospects in terms of actual cash. At the time of Palmer's letter Richmond was working for an employer in Calais and was earning money for his work. In a letter from Calais in November 1828, Richmond gives an account of what he has done:

'. . . I will give you a total of my life over here by which you will be able to judge whether I have spent my time well or ill. I have since my arrival which was on the 12th of August finished . . . a portrait of Mr Walters, life size, 7 Miniatures, 1 Drawing and sundry sketches etc., etc. (but none from nature). I have also in hand a small Portrait of myself on Panel with a design—and 4 paintings on glass, feet 2½ high. Which I am doing for a room for Mr W. . . . From here I expect to take between 20 and 30 pounds, now if I can at Paris increase it to £50 I will set out for Italy . . .

'. . . I was delighted to hear of your inflexibility about [studying] the Figure for though it is certain *you will not* any more than *Mr Blake* get a thousand a year by it, yet you will have what he had, a contentment in your own mind such as gold cannot purchase—or flimsy praise procure. Mr Linnell is an extraordinary man but he is not a Mr Blake . . .'

No; extraordinary man though he was, Linnell was not, as Richmond tersely points out, a William Blake. Over the years Palmer was to realize this forcibly enough and there were times when he must have seen in Linnell a frightening resemblance to those wrathful and thwarting presences which Blake himself conjures up in the dark labyrinths of his prophetic books.

While Richmond was slogging at his commissions in Calais, Palmer was working in the idyllic world of Shoreham, buoyed up with the hope that a thousand a year was still within his reach. Yet that letter of Richmond's from Calais, with its account of dogged industry and money earned, pointed a moral that was not lost on Palmer. By contrast, he could claim neither cash in hand nor any real likelihood of earning it. In the circumstances it is surprising that in 1831 Richmond should borrow £40 from Palmer, with which he hurried off to Gretna Green to marry Julia Tatum against her father's wishes. The manner of his marriage was in keeping with his character. A resourceful and determined man, Richmond did not believe in letting his chances slip. He knew that self-assurance and charm of manner were an indispensable passport to the highest social circles, and he cultivated these qualities as assiduously as he did his art. Almost from the start he possessed what Palmer never had—the gift of getting on.

Probably it was this launching out by Richmond which made Palmer's father decide that a more regular and profitable career was necessary for his son. A suggestion was made to Linnell that young Palmer might find regular work as an engraver. With this idea in mind, Palmer left Shoreham in 1833 and settled in a small London house, No. 4 Grove Street, Marylebone, situated in what he called the 'pigsty neighbourhood' of Lisson Grove. After Shoreham it must have seemed a grim and depressing change, but for Palmer there was some compensation in being near Linnell, who had an establishment in Bayswater, and also Edward Calvert, who was then living in Paddington. Palmer's only companions in his new house, which he had bought with the money from a legacy, were his old nurse Mary Ward and a favourite cat.

Palmer's father, it seems, continued to live at 'Waterhouse', so that the Shoreham connection still remained. The six subjects exhibited by Palmer at the Academy in 1834 were all Kentish ones. In 1832 and 1835 Palmer visited Devon, attracted there by the sight of a print of Combe Martin Bay which he saw in a shop window, and in the Academy of 1835 the first of

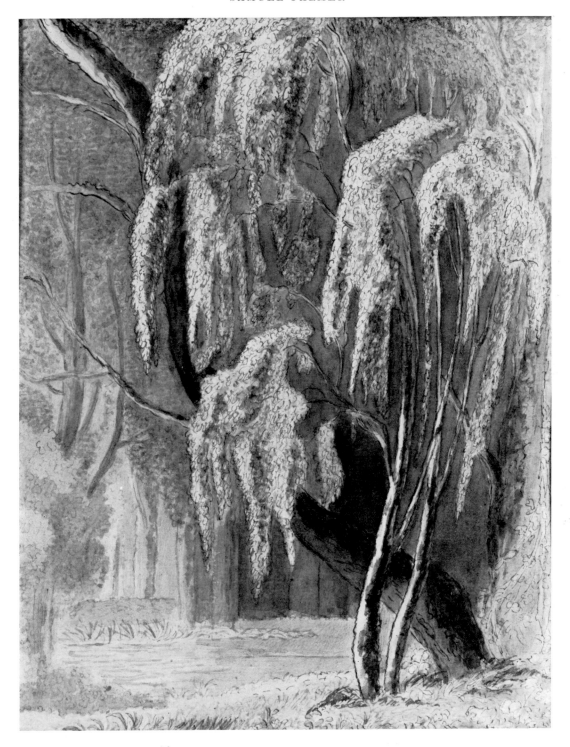

(viii) *Stream with overhanging trees. Sepia and grey wash*

his Devon subjects appeared. In later years Devonshire, with what he describes as its 'heaped-up richness', took the place of Kent as his ideal landscape, and in particular the country round Lynton and Lynmouth seems to have exerted on him an irresistible fascination.

In the same year as this second Devon visit Palmer made a journey to Wales in company with Henry Walter, one of the 'Ancients'. They went by steam-boat from London; and on the journey back travelled by way of Tintern. It was a longish tour and cost Palmer more money than he had bargained for. At Tintern funds gave out and Palmer had to write to George Richmond for a loan. This letter, headed 'Tintern Very deep Twilight Wednesday August 19th, 1835', rhapsodizes over the beauties of Tintern Abbey and the surrounding country.

. . . 'Such an Abbey! the lightest Gothic—trellised with ivy and rising from a wilderness of orchards—and set like a gem amongst the folding of woody hills—hard by I saw a man this evening literally "sitting under his own fig tree" whose broad leaves mixed with holyoaks and other rustic garden flowers embower'd his porch. Do pray come—we have a lodging with very nice people under the walls and three centuries ago might have been lulled with Gregorian Vespers and waked by Complin to sleep again more sweetly—but the murderer of More and Fisher has reduced it to the silence of a Friends' meeting house . . .'

Palmer completes the letter the following day in a very different tone. Instead of rhapsodizing over the beauties of Tintern and its abbey, he bewails the lack of cash with a kind of rhetorical gloom that suggests the despondent outpourings of Mr Micawber.

'Thursday Eveng. Poetic vapours have subsided and the sad realities of life blot the field of vision—the burthen of the theme is a heavy one. I have not cash to carry me to London—O miserable poverty! how it wipes off the bloom from everything around me. Had I conceived how much it would cost I would as soon have started for the United States as Wales—but I have worked hard—seen grand novelties and enlarged the materials of imagination—if I could but sell a picture or clean another Opie or two or—but I am all in the dumps "shut up and cannot come forth" and feel as if I alone of all mankind were fated to get no bread by the sweat of my brow—to "toil in the fire for very vanity"—If you've a mangy cat to drown, christen it "Palmer". . . .'

In this letter we see how easily Palmer succumbed to those sudden fits of pessimism which were to darken much of his life. He was one of those people whose moods tend to shift from one extreme to the other, and between exuberant gaiety and profound pessimism there was for him no middle path. It was perhaps a fear of the darker side of his nature that made him depend so much on the kind of human relationship where the ties of affection were strong enough to supply some element of emotional reassurance. By the law of things such relationships occur but rarely in a lifetime, and when they cease they leave a gap proportionate to the special place they filled.

A brief note in Palmer's pocket-book records an event which affected him more deeply than the simple wording may suggest. 'My dear Nurse, and most faithful servant and friend, Mary Ward, died at five minutes to five o'clock, 18th January 1837.'

It was Mary Ward who used to read Milton to Palmer when a child, and on her death-bed she gave him her old volume of the poet as a parting gift. With her death he lost not only a faithful friend and servant, but also a link with his childhood days and the wonderful world of Shoreham which was now behind him for good. It was perhaps with some thought of consolation that he now turned to the idea of marriage and a trip to Italy.

(ix) A wooded river-bank. Pencil

In the year of Mary Ward's death, 1837, he became engaged to Hannah, the eldest daughter of John Linnell. It was the fair-haired Hannah who used to lead the group of eager children when they ran out of Linnell's Hampstead cottage to welcome Blake and Palmer after their walks from London. Many times in those days Blake had taken Hannah on his knee and repeated to her his poems and stories. Through her upbringing and her contacts with the artistic world, she had developed a strong feeling for art, and she possessed, too, a respectable talent of her own. At the time of her engagement she was nineteen, young enough to share to the full Palmer's enthusiasm for the visionary and the ideal. Though with the death of Mary Ward he had lost a link with Shoreham and his childhood, he had in Hannah someone who had known and revered one of the key figures in his life—William Blake. Through her old memories and associations could be renewed, and that in itself must have been an added attraction for Palmer. And on her side marriage to him meant the sharing of artistic tastes and the chance of breaking free from the tyranny of her father's household. On the score of personal freedom, she and Palmer were to be disillusioned soon enough.

On September 30th, 1837, Hannah and Palmer were married, Linnell insisting, against Palmer's wishes, that the marriage should be a civil one. The ceremony took place at the

41

(x) *A Church, with a Bridge and
a Boat. Brush and brown ink
(Ashmolean Museum, Oxford)*

registry office in Marylebone, Calvert and Richmond acting as witnesses.

When it was proposed that the young couple should visit Italy after their marriage, Mrs Linnell raised innumerable objections about the dangers of the journey, the risk of fevers, the bad food, the papacy, the bandits.[1] For Palmer the main stumbling-block was finance. In the end he solved his difficulties by borrowing from Richmond, just as Richmond himself had defrayed the expenses of his own marriage by a loan from Palmer. On October 12th the Palmers, accompanied by George Richmond, Mrs Richmond and their little son Tommy, landed in France from the packet-steamer *Lord Melville* on the first part of their journey to Italy.

The rest of the journey, which took a month, was made in stages by *voiture*, the Palmers and the Richmonds travelling together as far as Rome. After a stay of some months in Rome, the Palmers parted company with their fellow travellers, journeying south to Naples. In a double sense it was a parting of the ways. For Richmond there were to come now all the rewards of personal and artistic success in the highest circles of Roman society to which his

[1] It was perhaps to placate Mrs Linnell that Palmer before leaving purchased a pistol and ammunition. Though during his stay in Italy he faced many real dangers, he was only called upon once to perform an act of self-defence. On this occasion, with his wife on his arm, he turned the charge of a wild cow on the Compagna by shouting at it and dashing the cover of his sketch-book in its face.

42

letters of introduction gave him easy access. For Palmer there followed what his son describes as 'the humiliating and penurious shifts, the hardships and sometimes the danger' of two years of impecunious travel, made possible only by desperate economies and a hand-to-mouth standard of existence. Every penny had to be counted and there was scarcely a moment when work could be laid aside. Yet the fact was that these years spent abroad, with Linnell's influence to some extent neutralized by the distance between Bayswater and Italy, were the only time in their married life when the Palmers enjoyed any measure of happiness and freedom.

It was ironical that the man whom Palmer had once called 'a good angel from Heaven' should have become so soon a thorn in his flesh. Even in Italy the dictates of the Linnell household were not to be escaped completely. Hannah's parents, for instance, objected to her painting out of doors; and on her father's orders she was put to the ceaseless drudgery of making copies from the Old Masters and at an early stage of the 'wedding trip', as Palmer called it, worked herself into a state of nervous collapse. For some of these copies she was paid by her father at the rate of seven shillings and ninepence each.

Palmer had hoped that through Richmond's influence he might find buyers for his art in Rome. He was disappointed. During his years in Italy he only managed to sell a single work, a water-colour of Rome purchased for forty guineas by a member of the Baring family, the introduction being made by Richmond. Palmer felt that Richmond might have done more on his behalf, as perhaps he might.[1] But his own lack of social judgement was largely to blame. His mode of dressing, for example, was not calculated to impress would-be patrons. A description of his sketching costume is given by the daughter of Richard Redgrave, R.A., in a memoir of her father.

'It was during a tour in Wales (either in 1835 or 1843) that my father and Cope first made acquaintance with Samuel Palmer the water-colour painter. They were sitting miserably enough round the inn fire, one sadly rainy day, when they saw a figure approaching the inn door, very wet, and very strangely clothed. They first took him for a pedlar, but the pedlar turned out to be a painter; his wares, pack, etc., were arrangements devised by himself for storing his whole painting apparatus, clothes, and necessaries of travel upon his own person.'

Commenting on his father's lack of worldly sense, A. H. Palmer says: 'It was characteristic that Palmer had prepared his appalling costume for the distinguished Roman society to which he hoped his work would appeal, precisely as he had prepared it for the British sketching tour during which Cope and Redgrave mistook him for a pedlar.'

[1] Richmond was, in fact, more generous to Palmer than the author of *The Life and Letters* cares to admit. In a letter to Linnell from Pompeii, 1838, Palmer writes: 'You ask if I have begun upon the borrowed money. As the travelling to Rome swamped my own money which I had saved, we were obliged to begin upon the other on our arrival there and having been abroad ten months, have remaining in hand two of Mr Richmond's £20 notes.'

In a later letter Palmer says that Richmond agreed that the loan should never be mentioned and that repayment could be made at any time convenient to Palmer. In addition to lending Palmer a substantial sum of money, Richmond also commissioned a drawing from Hannah for £10.

In contrast with Palmer's experience, Richmond's sojourn in Italy was financially profitable from the start. Taking with him from England a sum of about £255, he was able, by the commission he received in Italy, to bring home the handsome increment of £539.

(Richmond Diary)

(xi) *View at Lydford, Devon. Pen and brown ink*

No wonder potential patrons fought shy.

After their arrival in Rome with the Richmonds, the Palmers wintered there and found the climate more English than they expected. As Palmer told Calvert: 'The weather was for months very rainy, and (we being without a fireplace) so cold that I wore a waistcoat lined with flannel, and Mrs Palmer wrapped up like a Mummy.'

When spring came they moved on to Naples, going by way of Velletri, Terracina and Gaeta. Travelling brought its torment of fleas. In Naples, while looking for lodgings, they slept in what Palmer describes as 'a pestiferous little den with only a thin roof between us and the sun, in a bed not large enough for one person, with a window opening inwards to the shaft or funnel of the house, ventilated only by blasts from drains and kitchens, and in one of the most filthy streets . . .' The heat of Naples, however, suited Palmer and he enjoyed the 'perspiration of walking, like a tepid bath', feeling that the sun was only ripening him, as it did the plums and peaches.

From Naples, the Palmers later went to Pompeii, living there among the ruins for a month, in a room with an unglazed window. While they were there Vesuvius erupted, and at each thunderous explosion 'the makeshift door shook and the watchdogs bayed'. It was as if one of the ancient dead had wakened from his long sleep and was trying the door of his ruined house. In the evenings, to add to the romantic atmosphere, Palmer and Hannah read—appropriately enough—*The Last Days of Pompeii.*

Towards the end of the summer they returned to Rome. By this time Linnell was growing restive at their long absence from England. Writing to Hannah on July 30th, 1839, he hints that the Italian visit should now be brought to a conclusion, and he refers also to a streak of obstinacy in Palmer's character.

'The completing a tour like yours', he writes, 'is something like completing a picture. It may be spoiled by dwelling too long upon it, and should be ended suddenly; for going on

44

proceeds often from the habit of going on, rather than a clear perception of advantage. To know when to leave off is a great art in everything. If you can make your escape now, do not lose the opportunity, but come over the first bridge that presents itself to your notice. I wait, however, in despair of being able to influence the Governor, whose immoveable walk-through-rivers disposition, which he inherits from his no-thoroughfare-path-papa, I too well remember. I ought, however, to say what I can to cheer him up in his troubles, though I only say these things about rivers to help him over the bridge if I can; but he is such a neck-or-nothing man. . . .'

Those words of Linnell's, 'To know when to leave off is a great art in everything', was a maxim that he himself would have done well to remember. Far from knowing where to leave off, he carried everything to extremes—his theories, his industry, his prejudices, his arguments, and even (when it suited him) his studied show of deference and humility.[1]

In spite of Linnell's hint about concluding the Italian tour, Palmer was loath to return immediately. He proposed instead that the homeward journey should be broken by a stay in Florence to enable Hannah to make saleable copies from the Old Masters there. In a letter to Linnell, Palmer estimated that this work would take three months and would mean staying in Florence till the end of November. But he was worried by the extra expense it would entail and wrote to ask Linnell for his advice. Though this extension of the tour was finally approved of, the travellers were back in England by November.[2]

Writing to his father-in-law on what he calls 'our homeward march', Palmer gives an account of the work he intends to put in hand on his return—the mounting and touching up of his Italian drawings for exhibition, and also the painting of 'at least two really effective *pictures*'. But he adds: 'Now, whatever others can do, *I* cannot attempt this in a desolate, dirty house, such as was mine during Mrs Hurst's administration [Mary Ward's successor], with clothes hanging to dry in the passage; therefore I think and indeed feel sure that the only way will be, if the house is swept and garnished ready for us, to go into it at once with Anny.'

It was with tears in his eyes that Palmer took his last glimpse of Italy, knowing instinctively he was never to return. All his life he was to remember the grimness of that home-coming, the brutal contrast between the sunlight and marble palaces of Italy and the filthy Thames warehouses looming through the London fog. That disenchanting plunge into a London winter produced in him something resembling a traumatic shock. In some strange way he lost his ability to paint in oils, and everything he turned his hand to seemed doomed to failure. Yet for the time being, at any rate, financial difficulties were eased for the Palmers by the good prices they got for the sets of prints engraved by Linnell from the Michelangelo subjects in the Sistine Chapel. These engravings the Palmers had taken to Rome and coloured there directly from the originals. Hannah's copies from the Old Masters were also sold for good prices. When

[1] Constable records that when Linnell was soliciting votes on his own behalf for election to the Royal Academy, he 'spoke long to Landseer in Regent Street with his hat off all the time—I should not have wanted any other reason not to vote for him' (Constable in a letter to C. R. Leslie).

[2] At the beginning of September, Palmer had arrived in Florence, planning to make a prolonged stay there in order that he and Hannah might study the Old Masters and make copies of the things that impressed them most. But delays in getting official permission for this copying work made Palmer decide to leave Florence after a stay of only six weeks. So in the end it was Palmer's decision, not Linnell's, that settled the date of the homeward journey.

this source of income was exhausted Palmer had to face what his son calls 'the unspeakably weary struggle against the neglect and contempt to which education and gentle manners only serve to make a poor man painfully sensitive'.

It had been Palmer's idea to go back to his Shoreham studies and, with his Italian experience behind him, to make these studies the basis of new oil paintings. It was a plan that foundered at the start. Instead of enriching his vision, the vast impact of Italian art seems only to have weakened and confused it; and when he tried now to work in oils he was like a man struggling with a new and uncongenial medium. It may be true, as Palmer himself maintained, that had he had encouragement and technical advice at this time he might have got into his oils something of the old Shoreham spirit, or at least a technical mastery comparable to the ease and fluency of his Italian water-colours. As it was, his sense of failure here made him gloomily apprehensive about the future. A note written in 1840 speaks for itself. 'Supposing lessons stop, and nothing more is earned—avoid snuff, two candles, sugar in tea, waste of butter and soap . . . But it is more difficult at present to get than to save. Query. Go into the country for one month to make little drawings for sale?'

Two years later he records more factually the low ebb of his fortunes. 'Our professional experience, 1842. February 3, I went to the British Gallery, and found both my pictures and one of Anny's rejected. March. Mr Ruskin and others were shown our drawings. Mr Nasmyth was to name me as a teacher to Admiral Otway. I offered Miss B—, Addison Road, to teach one pupil for 10s. per annum. [At a school.] Went to British Artists, and found one picture hung near the ceiling, another rejected, and Anny's *Job* rejected. Mine were the same pictures I sent to the B Gallery, for the new frames for which I had paid £5. 8s. 0d.'

In January 1842 Palmer's eldest child was born and was named Thomas More after the great Sir Thomas More, one of Palmer's heroes. In the summer of this year Palmer took his family to Thatcham in Berkshire, where they stayed from August to October. Sketches made during this visit were exhibited at the Royal Society of Painters in Water Colour. In the following year, to Palmer's great joy, he was elected an Associate of the Society and could claim at last to have attained some official standing in his profession. The sale of a drawing for £30—then a large price for him—at the Society's Gallery set the seal on his satisfaction.

In September 1843 he made a sketching tour in North Wales. As usual with him, the expedition was undertaken with the minimum of equipment and at beggarly expense. A. H. Palmer gives a detailed description of the kind of outfit his father carried with him on tours. 'A deal case or a portfolio slung round the shoulders with a strap held a good supply of paper, together with two large but very light wooden palettes coated with home-made white enamel and set with thick clots of colour so prepared as to be readily moved by the brush or finger. A light hand-basket held a change or two of linen, reserve colours, an old campstool which had seen service in Italy and, when necessary, the lunch or dinner. The coat was an accumulation of pockets in which were stowed away the all-important snuff-box, knives, chalks, charcoal, coloured crayons, and sketch-books, besides a pair of large, round, neutral-tint spectacles made for near sight. These were carried specially for sunsets and the brightest effects on water . . .'

The hardships and difficulties of travel were cheerfully accepted by Palmer, who possessed a constitution of surprising resilience. 'In exploring wild country,' he once wrote, 'I have been for a fortnight together uncertain each day whether I shall get a bed under cover at night;

From the back of Glenlyn, looking up the River Lyn.

(xii) *View of the River Lyn. Pencil*

and about midsummer I have repeatedly been walking all night to watch the mystic pheno-
mena of the silent hours.'

Once while weatherbound in Wales he read a seven-volume edition of Richardson's novel
Sir Charles Grandison; and on another occasion he was compelled, after a drenching, to lie in
bed while his one suit of clothes was being dried out by the inn fire. On these sketching expedi-
tions he not only filled many pages of his sketch-books, but also made copious illustrated notes
on separate pieces of paper. These he stored away in a special portfolio labelled 'Written
Memoranda', and in later years they often supplied the basis for more elaborate drawings.

Early in 1844 Palmer's second child, Mary Elizabeth, was born; and in the autumn of this
year Palmer went to Guildford in something like his old Shoreham spirits, if we can judge by
his ecstatic delight in the rich September landscape where 'the living chequer-work of the
shadows' lit up the whole 'with a dance and dazzle of splendour'.

In his notes dated Guildford 1844 he analyses the effects of light and shade with the dual
sensitivity of the poet and the artist. 'The first thing that struck me on coming here,' he writes,
'was the POSITIVENESS, INTENSE BRIGHTNESS, and WARMTH of the
LIGHTS; and that the shadows are full of REFLECTED LIGHT, though very deep . . .

47

'The shapes of the focal lights and touches must be thoroughly understood and drawn to give any chance of imitating the vivid splendour of nature's lights. The shadows in nature are very deep compared with the wonderful light; and themselves, nevertheless, are clear, beautiful, and clean in colour, and full of reflected light, warm and cool. The smiting of the light upon the shade is accomplished by its opposite, viz. endless play and graduation. Nature seemed WARMER than ever, but with a perpetual interplay of greys.

'Some of the conditions of the glitter in sunshine IMPORTANT: Holes in dark. Cast shadows; as well as the incessant play of the common shadows.

'To a black or dark animal and a white one, all the landscape—excepting stubble fields and suchlike—will be a MIDDLE TINT.

'Glitter of a white or very dark object will be helped by its SQUARENESS of shapes, GENUINE MIDDLETINT of its BACKGROUND, a mass of something relieving dark near it, and the play of CAST SHADOWS and HOLES of dark, which are the enrichment of nature's breadth. These, I think, govern and mass the varieties of colour in banks of wood, etc., and make smooth, enamelly hills precious.'

On a slip of cardboard Palmer summarizes and restates his observations. '1844. WHITE IN FULL POWER from the first. Remember blazing days wherein it makes middle-tint colours in sunshine seem dark, AND GREYS COOLER THAN WHITE. WHITE NOT TONED WITH ORANGE, but in juxtaposition with the PRIMITIVES.'

'DEADLY DARK BROWNS LAID ON AT ONCE.'

'FLASHES of LIGHT, or BLOW OF DARK. To get vast space, what a world of power does aerial perspective open!

'From the dock-leaf at our feet, far, far away to the isles of the ocean. And thence—far thence, into the abyss of boundless light.'

After his stay at Guildford, Palmer went for three weeks to Wales, where he continued his painting and the collecting of written memoranda. Yet in spite of all his efforts 1844 was financially the leanest year he had had since his return from Italy and it was only by the continual fag of teaching that he managed to keep himself afloat. But like an optimistic general who has lost a battle, he began at once the preparations for a new campaign. 'If spared to September, 1845,' he wrote, 'a batch of imitation.' By 'imitation' he meant subjects taken directly from nature with only a minimum recourse to stylization and imaginative treatment.

This faith in nature is reaffirmed by the following entry in his notebook. 'April 1845. When huffed by bad hanging retreat for strength, not to popular style, but to NATURE. . . . Plan of 1845 D.V. Paint from *Effect* and *Colour* sketches.'

In this year Palmer spent a great deal of time at Margate with his family, and was also at Princes Risborough, Buckinghamshire, for about a month. While at Princes Risborough he worked at 'a batch of imitation', a series of detailed landscape drawings, one of which, 'A Farmyard at Princes Risborough', is now in the Victoria and Albert Museum.

Yet however faithful the process of imitation was, some element of the essential reality was lost and had to be recreated by the resources of art. Palmer recognizes this in a note written during his stay at Princes Risborough.

48

from my bedroom window. Myrtles in full blow.

(xiii) *View of Lynmouth* (?) *Pen and black ink*

'After having studied here for a month, my general impression with regard to effective painting and the conduct of [a] picture is this.'

'The bask of beautiful landscape in glorious sunlight is in nature perfectly delicious and congenial with the mind and heart of man, but the imitative power is so limited—particularly so as to the lowness of the light pigments with which we imitate—that the above, when upon paper or canvas, should perhaps only be considered as the corpse which is to be ANIMATED.'

And in a later section of his notes he goes on to enumerate the methods by which this animating process may be achieved.

'How,' he asks, 'is that wholesome, clean, and unpicturelike appearance to be obtained, which on every side delights one in every country walk? 1st by a more fresco-like treatment, not spreading juicy colour too widely. Secondly perhaps, also by remembering that the greater proportion of matter out of doors is a medium far removed from the coldest blue and the most

49

gaudy yellow and orange. Hence a grey cottage side and a yellow tree tell in nature and have their just value. Thirdly by patience, in ripening the masses and illuminated matter; for what would nature be without its delicate playfulness of things into each other; its infinity and endless suggestiveness. Now this can be imitated in a hurry neither in copying out of doors nor in painting at home. Fourthly by keeping the variety of the palette ALIVE. For a bit of nature, however small, refuses to be copied by any impatient dab or idle spread of one colour. Think of a grey stem with lichens and mosses, rich as a cabinet of gems, or think of a single piece of rock. Now how contemptibly do we imitate this with a few dabs and patches of colour.

'All this is only one little corner of Art. The conclusion of the whole matter is this, that it is almost impossible to do rightly or wisely. That conceit, self-complacency, and indolence, should be incessantly hunted out of the inner man. That everything we do should be done with all our might, and that rest and recreation should be proportionably separated and entire. What a blessed thing is sleep to a mind always on the rack for improvement!

At about the time of his 'retreat to nature' note Palmer was also formulating under the heading of 'Designs prudentially considered' some guiding principles for making his art more attractive to the public.

'1st SUBJECTS. A subject should be interesting either from its BEAUTY, or ASSOCIATIONS, or BOTH; OBJECTS or SCENES, intrinsically BEAUTIFUL.

'2nd SUBJECTS in which ELEMENTS, or their combinations or secondaries, are the principal matters, as such in which are expressed DEW; SHOWERS or MOISTURE; THE DEEP-TONED FERTILIZING RAIN-CLOUD; DROUGHT, with its refuge of deep, hollow shade, and a cold spring; the BROOK; THE GUSHING SPRING, or FOUNTAIN; AERIAL DISTANCE.

'3rd LIGHT either produced by its great enforcer cast shadow, or by great halved opposites, as when the sun is in the picture.

'4th DARKNESS, with its focus of coruscating light, and a moon or lanthorn. The precious and latent springs of poetry are to be found here.

'FIGURES, which in landscape are an adjunct, should if possible be in ACTION, and TELL A STORY.

Yet in spite of all these attempts to discover what constituted the selling qualities of a picture, the 'buying classes', as Palmer called them, remained indifferent to his work and only the barest income was earned. For a set of four illustrations to the first edition of Dickens's *Pictures from Italy* which appeared in 1845, Palmer received from the publishers £21. And from the years 1843 to 1853 the total of his sales, including several works in oils, amounted to only £45, an average price of under £16 each. No wonder he was glad to teach on almost any terms.

It is probably more in despair than hope that he writes in his notebook: 'I must, D.V., strike out at once into a NEW STYLE. SIMPLE SUBJECT; BOLD EFFECT. BROAD RAPID EXECUTION; rounding the chiaroscuro without timidity as to the blotting out little lights, when the leaving them precise and sharp would involve premature niggle—using the Globe Principle with power and boldness. . . .'

In December 1847 Palmer's daughter died. Edward Calvert, Palmer's friend of the Shoreham days, did what he could to comfort the bereaved parents; but the little house in Grove Street had now become such a place of sorrow that the Palmers at last abandoned it, and in

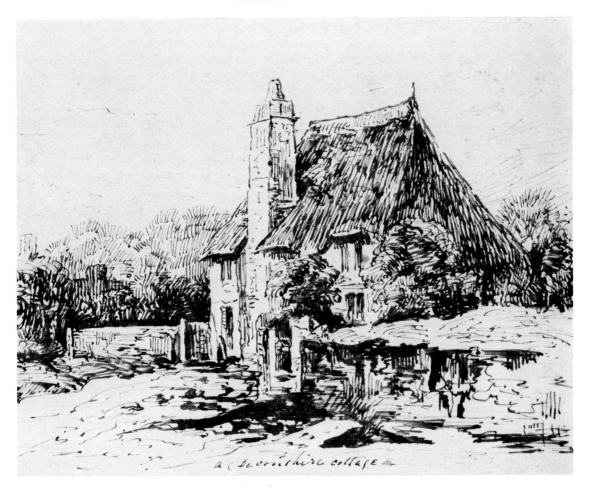

(xiv) *A Devonshire Cottage. Pen and ink*

the spring of 1848 moved to 1A Victoria Road, Kensington. Three years later they moved again to No. 6 Douro Place, a neighbouring street.

According to Palmer's son, No. 6 'was a small ugly villa . . . semi-detached from the piano of an ultra-modern, geranium-growing family next door. So vigorously did the neighbours protest against the weeds allowed to mature as lessons to pupils, that there was no resource but the scythe.'

By the time Palmer took up residence in Douro Place he was fully in the grip of Victorian social life. The visionary dreamer of the Shoreham days who had once believed that 'the expenses of one person living as an epic poet should live' could be cut to 5s. 2d. a week was now saddled with the cost of keeping two grown-up servants, together with all the expenses of an active social life. It was not so much that the dreamer himself had changed, but that two-thirds of his income was now derived from teaching, and social amenities were a necessary part of the regime. One suspects, too, that John Linnell, Palmer's father-in-law, who was now becoming a fashionable and successful artist, was watchful of his daughter's social status and

took good care to ensure that Palmer maintained her in a style that in no way detracted from his own social position.

As time went on the aggressive and dominating personality of Linnell encroached more and more on the domestic life of the Palmers. The description A. H. Palmer gives of the Linnell household after its move from Bayswater to Redhill, Surrey, is richly revealing. 'Here', he says, 'Mr Linnell now ruled his small dominion of "Redstone Wood" as independently as an eastern chief. Designing his own house, and personally supervising the fitting of almost every block of stone in its strong walls, he had so placed it on the brow of a well-timbered hill sloping towards the west that it served as his observatory for those effects for which he was soon to become celebrated. He had, as it were, fortified a stronghold in the midst of the placid and conventional country society, and there revelled in his art, pored over Greek and Hebrew, ground his corn, baked his bread, brewed his ale, and thundered forth his denunciations of men and opinions that displeased him; being aided and abetted in all he did by a family to whom, for the most part, every word of his was an irresistible ukase.'

It was Palmer's misfortune to hold the sort of political and religious opinions that his irascible father-in-law habitually denounced. And another source of friction was the new independence shown by Hannah, who, against her father's wishes, had accepted the Church of England form of worship shortly before her marriage to Palmer.

In spite of the added expenses of the house in Douro Place, it provided only limited accommodation. There was, for instance, no room for a proper studio, nor even adequate space for the pupils' crinolines. Except in the financial sense, the kind of teaching that Palmer did was anything but rewarding. With a few of his pupils, as, for example, Louisa Twining and the daughters of George Richmond, he had at least the satisfaction of forming a lifelong and stimulating friendship, but in the majority of cases, to judge from what he wrote in later years on the subject of teaching, the art instruction he gave was little more than a humiliating sale of talent. As a general rule, he was expected to produce a painting or drawing to which the lady pupil added a finishing touch or two and possibly her signature. The work was then passed off as entirely her own and on the strength of it she could claim an ability to paint among the string of her accomplishments. 'In nine cases out of ten', Palmer wrote, 'people don't want real teaching for their daughters, but some fine touched-up drawings to show in which they do not reflect themselves but their masters.'

All that can be said for this absurd Victorian pretence is that it put money in the pockets of artists who might otherwise have starved. Certainly Palmer could not have practised the sort of art he did if there had been no income from teaching to fall back on. But if it provided a source of ready cash, it also cut desperately into his time and made him doubly anxious to succeed as an artist. For if he failed to sell his work in exhibitions, what 'pull' would he have as a teacher? And might the day not come when pupils drifted away, preferring the services of some more fashionable and successful master?

Under the stress of these misgivings Palmer resorts again to his notebook, to the technique of self-examination and forumulated resolve.

'Never hurry for exhibitions,' he writes, 'but from the Autumn of 1850, D.V., carry on a continuous movement of works for sale. Endeavour after oil pictures. What are the secrets of a proper rapidity. 1st? Decision in the first design—seeing the *whole at once*. Trying after indicative formation of the central difficulty. After a studious and careful preparation, instead

(xv) *Portrait of Samuel Palmer by George Richmond. Pencil*

of aiming at finish aim to execute the mental vision with as little manipulation and as much inventive energy as possible; doing only what I see . . . A deep, Gray Day a good subject. Coincident with other things will be an attempt at a New Style. Forswear HOLLOW Compositions like *Calypso* and *St Paul*, and forswear great spaces of sky. TAKE SHELTER in TREES and try the always pleasing arrangement of white cloud behind ramification, and reflex in water; also sheep foregrounds . . . I am inclined to think that a sketch in one colour, with all the principal parts and striking completed effects, would be a very sure foundation, and the painting from its comparatively easy. Try something like the solid BLOCKS of sober colour in De Wint. . . . Why do I wish for a NEW STYLE? 1st. To save time. 2nd. To govern all by broad, powerful chiaroscuro. 3rd. To ABOLISH all NIGGLE. . . .'

Yet in spite of all this self-counsel and the desire for a new style, in spite of a resolve 'not

53

to be solicitous about the brightness of little specks of light', Palmer had enough self-know-ledge to see that his art, no matter what he did, would remain essentially the same. Towards the end of these notebook entries he tacitly admits as much, and he realizes, too, that it is this fatal quality of individuality which alienates from the public. One can almost hear the sigh with which he writes: 'Try to have in progress a number of small subjects in which extreme fewness shall be the charm—for I fear that I have neither power nor inclination to do anything which is not in some way or other strongly characterized. . . .'

For Palmer life in the villa world of Kensington was an exile from everything he loved and valued most. Here in the isolation of respectability he found a symbol of free, untamed nature in the weeds that were allowed to flourish under his window.[1] And as a reminder of Shoreham and the beloved countryside of Kent he planted a root of hops among the lilac bushes. Indeed, so much did he dwell now on the brighter days of the past that even the Italian organ-grinder was encouraged to perform outside the villas of Douro Place for the memories he evoked of the two happy years the Palmers had spent in Italy on their 'wedding trip'.

Yet even Kensington was not without its compensations. While living here Palmer made the acquaintance of many distinguished artists who remained staunch friends throughout his life; and it was at this time that he was elected a member of the Etching Club, an honour that stimulated his interest in a form of art in which he ultimately achieved an astonishing mastery. From Kensington he escaped periodically on sketching expeditions to Devon and Cornwall, where he steeped himself in the rich pastoral scenery that always so entranced him. As usual on such expeditions, a great deal of ground was covered.

'I coasted round as far as Ilfracombe [he writes]—waterfall into the sea—then back, and landed at Combe Martin, walking home to Berrynarbor. We must take the trouble to map out and paint with the different local colours arable land and garden, which come in every variety of rows and patterns. Also woods and woody hills must be juicy and rich; real TREE COLOUR, not anything picture colour. Detached, elegant trees sometimes stand out into the glade; and above the woody or arable hill-tops, a bit of much higher hill is sometimes visible, [all] heaving and gently lifting themselves, as it were, towards the heavens and the sun. It is of no use to try woody hills without a wonderful variety of texture based on the modelling. . . .

'NEVER FORGET THE CHARM of running water.[2] In Berrynarbor valleys it gushes everywhere. O! the playful heave and tumble of lines in the hills here.'

As time went on life in Kensington became for Palmer a virtual imprisonment. Much as he longed to work in the country, he was tied to London by the necessity for teaching and also by the better facilities it provided for the education of his son More. A great deal of his time in Douro Place was now spent alone, because, it seems, the Linnells still regarded their daughter Hannah as an appendage of their own household and could never bring themselves

[1] Under a chalk sketch of dandelions, daisies and grass tufts from his garden, Palmer added this note in pencil: 'Farewell soft clusters the only pretty things about the place. Ye are to be mowed this afternoon and to have a scraped scalp of "respectability".'
[2] For Palmer the charm was irresistible. Once at Margate, seeing a stream of water flowing across the sand, he at once sat down to paint it without ever suspecting that the subject he had chosen was the outfall from the town sewer.

54

(xvi) *Pastoral Scene. Black chalk and water-colour*

to think of her as Palmer's wife.[1] The letters Palmer wrote to Hannah during her long recalls to 'Redstone Wood', the parental home at Red Hill, reveal the growing strains these prolonged absences put upon their marriage.

The first real breach with Linnell appears to have developed during the summer months of 1849, when Palmer had taken his family to stay with the Linnells at Red Hill. Then, as so often in Victorian times, a difference in religious views proved the stumbling-block. Linnell suspected that Palmer had leanings towards ritualism, and Palmer in a letter to his wife makes a clear declaration of where he stands in the matter of religion. 'That we may never have in future to misspend time in the deplorable mischief of religious controversy, pray understand, as I thought I often mentioned, that I am no Puseyite, but a most unworthy member of the Church of Christ, in common with everyone of those poor children at the Philanthropic Farm School; that if I have any "religious views"—if I may use that disagreeable expression—they are about equally unfavourable to the Manning School and to Puritanism.

'I have no doubt that the worship of the primitive Christians was a musical service, and therefore always prefer a chanted ritual to a read one; but I should not frequent any church, nor have ever done, where I thought that such ritual was accompanied by false doctrine, unless it were the only church within reach . . .'

Nearly ten years later, in 1858, the lonely prisoner of Douro Place writes to Hannah: 'It

[1] There are letters in existence which hint that Linnell's relations with his daughter were of an incestuous kind.

55

will require such undivided attention to maintain and, D.V., improve the step which I have for the last two or three years, by the kind providence of God, made in public estimation, that for the future, when I settle down to my exhibition work it will not do for you to be absent. Therefore if you wish to *stay* at Redstone this year, it must be *before* I get my peep at Devonshire. I must therefore forgo the harvest, and take my chance for a shot with the partridges over the stubble; and in the meantime with my increased power of making use of nature, I believe I am losing hundreds—eventually, perhaps thousands of pounds. For were I now in some healthy country place with my materials, I might be making, partly out of doors, besides my more complicated exhibition drawings, some of those a positive commission for which I have refused, leaving the matter open . . .'

And again writing to Hannah in the same year: 'I can *begin* my subjects better in London, but when *Italian* weather sets in, I should like to go out of town directly, if it were only for a week, and take my drawings with me. The weather from which I get my subjects and my suggestions for the remainder of the year is that dazzling weather when all the air seems trembling with little motes. A week of that is, to me, worth three months of ordinary fine weather. It is then I see real sunsets and twilights.'[1]

Palmer's plight was made worse by the attacks of asthma from which he had suffered since his return from Italy. Writing to Hannah from Hastings in 1859, he describes his susceptibility to dust and a dry atmosphere: 'I feel a strange relief since the squally, strange change in the atmosphere. Before the two thunderous days, it was what I call gasping weather; but since, although very close for this airy place, there is a delightful humidity in the air. I felt while the rain was pouring down, the refreshments which I suppose a plant feels under the same influence, after drought. I DREAD the DUST of town, which withers me whenever I get out; and if I could have my choice would prefer a month's incessant rain. You must see what an affliction it must be to me, anxious as I am after high excellence, to be as it were dodged and disappointed in all my attempts to get a sight of beautiful nature and strength to use it . . . O! that I were nestled among those granite taws of dear Devonshire, 1500 feet high.'

In spite of being at Hastings, Palmer remained ill and dispirited. 'I have been very quiet and undisturbed here, which is much in my favour', he writes later. 'I do not care about these things on my own account. I could go quietly like a poor sheep under the first hedge and lie down and die, so far as that goes; but as a living flour-mill which has to grind corn for others, it is a source of alarm to feel that the machinery is quite out of order . . . I seem doomed never to see again that first flush of summer splendour which entranced me at Shoreham . . .'

Not only was Palmer himself unwell, but his son More was now showing signs of mental exhaustion and overstrain. By the spring of 1861 More was feeling the need for a complete rest. He was then nineteen, a youth of great promise and so successful at school that his father had high hopes of his winning a university scholarship. Besides having a taste for English literature and the classics, he was a good musician and shared his father's love of

[1] What 'real sunsets and twilights' meant for Palmer is shown in two characteristic notes of his. 'Finest twilights (with moon) of all, I think, which add to full splendour of colour the mystery of transparent vaporous gloom. Observed in Cornwall and at Margate after evening Church, July 18, '1860. Thoughts on RISING MOON, with raving-mad splendour of orange twilight-glow on landscape. I saw that at Shoreham.'

(xvii) *Coast Scene with Passing Rain. Chalk and grey wash*

church choral music. Palmer, alarmed by his son's state of tiredness and inertia, looked round for some place in the country where More could spend a recuperative holiday. After much searching, a lonely farmhouse was found in the neighbourhood of Dorking. There Palmer settled his family and then reluctantly returned to the house in Kensington to struggle on with his art and the fagging work of teaching.

In April 1861 he wrote to a friend: 'You will be pleased to hear that poor More is really better. They are all crammed into a little farm house just on the top of Leith Hill, the summit of which is 900 feet above the sea level! More just crawls about and vegetates, and has taken my violin—is perhaps at this moment frightening the pigs with his first scrapings . . .'

Separated from his family, Palmer spent the cold, wintry spring in London. Unwell and in low spirits, he writes a letter to Hannah which seems to carry all the gloom of London with it.

'Today, Thursday, is like yesterday—thorough influenza weather. East wind, damp, cold, and fog. The houses in Albert Place loom through a dirty yellow fog, and the top of a tree in Kensington Gardens is but just visible. The gloom just now is overpowering. The London fog is hovering over like a pall. The cold makes one's fingers ache after washing . . . And as to outlining, designing, inventing, it has been quite out of the question. Depressed as I am, I

have still the English *will* about me—to fight to the last and die at my post. I think, D.V., I may yet conquer by taking in a whole system-full of new blood from nature.

'Half-past eight. The darkness increases, and the foul smells of London come in through every crevice.'

Later, in spite of 'the English will', Palmer has to admit that he can carry on in London no longer. In a letter to Hannah dated May 1861, he proposed joining his family at 'High Ashes', the farmhouse on Leith Hill where they were staying.

'I am too poorly to work any longer here, and I should spoil everything I touch, so I think I had better come, and then we can all consult as to what is best . . . The spare room will do very well for me it becomes warm to work in it without a fire . . . I think the thing to save us, D.V., would be four months, or five, of my work in the country. . . . If I cannot come after all, and settle to work, I ought to know at once; but *dreadful* waste of time seems to be my lot, much as I desire the contrary. . . . When will it all end? I really think, much as I hate rash steps, that poor Kensington is no longer the place for us. . . . O! my poor work. Guineas are being lost by hundreds, in losing the spring.'

And in a letter to More, written in the same month, he explains why the country is so necessary to his art at this particular time of the year:

'The month of May is always more prolific in the effects I paint than any other; and as my drawings are *avowedly* hung out of the way because they are said to kill everything else,[1] I think of trying one or two cool ones this year; perhaps of early mist clearing up over the distant country (but my kind of cool effects do not last beyond the month of May), nor will anything but wide prospects and a range like that of Leigh Hill suit me. I am therefore anxious to come down as soon as possible . . .'

In the end Palmer made his escape from the gloom of London and joined his family at 'High Ashes' farm. Full of hope for More's recovery, he went about filling the pages of his sketch-books with the pastoral subjects he so much loved. Not only was there the farm to delight him, but also a landscape rich in streams and valleys; and on the higher ground great pine woods and tracts of knee-deep heather. But the fresh air and the countryside in which Palmer revelled brought no real sign of recovery in the ailing More. By the middle of May, Palmer records, there was a change for the worse. For a time More was able to walk slowly with the aid of a stick, then had to be taken for outings in a donkey-chaise, propped up with pillows. Still hope was not abandoned. On July 2nd More himself wrote to a friend that he believed the crisis of his illness had passed. Nine days later he was dead.

Though Palmer had been prepared for the news, the shock of it sent him rushing from the house in a paroxysm of grief and he never re-entered it. In a state of collapse he was taken by the doctor to the house of his brother-in-law, James Linnell, at Red Hill. For months afterwards he remained in a stupor of grief, his faith shaken to its foundations and his whole life clouded with despair. Now, as he put it, every morning meant 'the painful stooping, as it were, to take up the burden of the coming day—a longing to be let off; a feeling of utter incompetence to the task; no hopeful motive and no strength'.

And behind the grief was the agonizing consciousness that he had perhaps unwittingly

[1] It is interesting to note that Palmer's brilliancy of tone, like Turner's, made him a dreaded neighbour on exhibition walls. But with the more illustrious Turner there was never any question of hanging him out of the way, and tamer colourists had to reconcile themselves to being eclipsed.

caused his son's death by encouraging him to work beyond his strength. A sense of his own worldly failure had made him pin all his hopes on More and now that he was dead there was a double agony in the thought that his own eagerness for the boy's education and success might have led to an overtaxing of his brain.

Once again in the dark hour of bereavement it was to Edward Calvert that Palmer immediately turned.

'As you are the *first* of my friends whom I set down to make partaker of my sorrow, I will not wait for black-edged paper, which is sent for. You I take first, for you were first in kindness when dear little Mary was called away, and your *kind, kind* heart will be wrung to hear that at our lodging at High Ashes, near Dorking, on Leith Hill, my darling Thomas More left us at a quarter to six. It was effusion of blood on the brain.'

The death of More closed another chapter in Palmer's life and art, as the move from Shoreham had done over a quarter of a century before. The house in Kensington was now given up, and for a time the Palmers settled in lodgings on Red Hill Common. In September 1861, after fruitless efforts to find somewhere else to live, a cottage was taken at Reigate. The dampness of the place, however, crippled Hannah with rheumatism and she fled to her parents' home at Red Hill. After spending six miserable winter months in the cottage, alone, Palmer began again the task of house-hunting, exploring every part of Surrey for a house near a railway station and within easy reach of London. London, he felt, was still a necessity to him, since it could provide a lifeline of teaching if the income from his art failed him. For a time he considered settling at Haslemere, a place that had always delighted him, but nothing came of the idea. Eventually, in an ill-starred moment, he was lured back to the neighbourhood of Red Hill.

The house he finally chose, 'Furze Hill House', near Reigate, Surrey, was a new and pretentious villa, a symbol of all that genteel modernity which Palmer so much despised. Besides being pretentious and inconvenient, it had the fatal disadvantage of being within strolling distance of John Linnell's home, 'Redstone Wood'.

Looking back long after his father's death, A. H. Palmer comments bitterly: 'Of all the blunders of my father's career, none was greater, so far as he himself was concerned, than the choice of a new house so close to the famous despot and almost incredibly unpacific painter of peaceful and beautiful landscape.'

The low opinion Linnell had of Palmer is reflected in a note written by Linnell's son and intended by him to be included in a 'Life' of his father. Palmer is described here as 'Having a mind too fanciful and wild; extravagant; *not controlled sufficiently by reality and sober truth*'; as 'indulging in fanciful sentiment'; and of '*living in an atmosphere of sentiment, imagination and feeling not always in touch with truth and real fact.* His sentimental state of mind (called by some poetical?!!) leads him to descriptions that are partly fictitious, mixed with humour etc.'

This humorous turn of mind which the Linnell family always misunderstood and disliked helped Palmer to bear more philosophically the uncongenial nature of his new surroundings. In mock deference to the pretentiousness of his neighbours he called his own drawing-room 'The saloon'; one bedroom 'The boudoir', another, which was damp, 'Bronchitis bower', and a little downstairs store-room 'The butler's pantry'.

Palmer's contempt for the cult of gentility which Linnell considered indispensable to the

winning of social status and the successful pursuit of art, was another point of difference in the sorry history of their relations. Yet Palmer, it seems, never openly protested. For the sake of appearances, he acquiesced in a display of bourgeois affluence that he never possessed or even aspired to. For the rest of his life, to satisfy his despotic father-in-law, he submitted to the tyranny of housemaids and the cyclonic upheavals of an annual spring-clean. At 'Furze Hill House' there was again no studio and Palmer had to work in a little den of his own, purposely kept ramshackle and untidy as a silent protest against the prim domesticity that surrounded him.

Writing to a friend in 1880, Palmer says: 'Our "Spring-cleaning" this time has been unspeakable. Hall and drawing-room *wholly* covered with a better carpet than Brussels—namely Wilton—price altogether something short of £40!!'

One consolation he possessed was the garden with its distant views of the Surrey and Sussex downs, seen over slopes of furze and heather. The hedges below the house were haunted by whitethroats and nightingales, and the encroaching suburbs had not yet banished the rabbits and the squirrels. In the matter of weeds he was luckier than he had been at Kensington. There were no neighbours near enough to protest against the scattering of unwelcome seeds, and though the cultivation of weeds was frowned upon as ungenteel, he was able by surreptitious methods to keep them flourishing. Even when some insensitive hand pulled them up and tossed them over the hedge, he would retrieve them or put others in their place. So insistent was he in the encouragement of weeds that he was eventually allowed to cultivate a small patch of them under his study window.

To Miss Redgrave, a favourite confidante, he writes: 'I *will* have my weeds though.[1] The white convolvuli are commencing their tortuosities (to speak in Reigate dialect), and Herbert has made a bench for the arbour. Miss Mary [a new housemaid] commenced weeding the other day, and pulled up both my hairbell roots, that I have been coaxing for three years into the garden.'

A. H. Palmer says that he never saw his father do anything with greater care and pleasure than the individual watering of his precious weeds in dry weather. These weeds and his shabby little study with its whitewashed windows to blot out the ugliness of 'Housemaid Vale', were Palmer's form of protest against the prim gentility in which he was now inescapably exiled. Again to the favourite Miss Redgrave he writes: 'Conceive if you can of the stagnation here . . . the creeping hours are the more weary, as each creeps along with a hod of mortar on her shoulders to multiply hideous slate-roofed villas. . . .'

Yet for all his miseries, Palmer never moped. In his ungenteel study at 'Furze Hill House' he created that 'little charmed circle of quiet' which was for him one of essential things of life. In a sense that room was an escape from all those bourgeois codes and standards which he found increasingly alien; but it was also, like the cloister and the anchorite's cell, a refuge of the inner life, a place where the artistic vision could germinate and fructify.

'The study', A. H. Palmer tells us, 'had a very pronounced sentiment of snugness about it, being neither too orderly, nor too empty, nor too large. A bow window of western aspect looked out upon Leith Hill, and the curtained shelves which lined the opposite wall bore a

[1] A. H. Palmer records that below Palmer's house was 'Mead Hole', renamed by the jerry-builder who had smothered it with stucco and brick, 'Mead Vale'. Palmer's friend C. W. Cope, at his first visit, looked down at this horror and directed his next letter to 'Housemaid Vale'.

heavy load of plaster casts from antique gems and busts, wax models of the figures of designs which were in progress, many colours, and many books. Here lay one of the beautiful smock frocks, once worn by so many of the peasantry, there a relic of Mary Ward—her battered tin ear-trumpet; and there again unstrung and silent, the old violin, once eloquent with many an ancient air on the banks of the Darent. Some much larger shelves on one side of the room held, in classified portfolios, the innumerable sketches of all sizes, all degrees of finish, and in all materials; a long life's selection from much of the choicest scenery in England . . .'

'Next to the easel stood the painting-table, which on examination, revealed itself as an old washstand! Now, it creaked under an unwonted load, consisting of a large rack full of china palettes; under brush-cases, mugs, saucers and gallipots; most of them containing the rich succulant masses of colour my father delighted to use, mixed with the last of a long series of vehicles invented successively, since the days of the notable 'egg-mixture'. . . .

'It was in the cosy but shabby little room I have described, that my father's most ambitious works were completed, his letters written, and his literary recreations so ardently pursued.'

During his later years at 'Furze Hill House' Palmer's financial circumstances improved. Thanks to the Victorian boom in art he was able to get higher prices for his drawings and there were also numerous commissions. In 1863 the sale of one of his drawings at an exhibition of the Water Colour Society led to the emergence of his one and only patron.

The buyer of this drawing, L. A. Valpy, was a lawyer who combined a taste for art with what A. H. Palmer describes as 'a business-like shrewdness and caution worthy of a veteran merchant, and the astuteness of an experienced equity lawyer'. Not long after the purchase of Palmer's drawing Valpy asked to be shown anything that the artist had in hand which specially affected his 'inner sympathies'. At this particular moment Palmer was reverting to an idea that had been simmering in his mind for twenty years—the designing of subjects from Milton's poetry. He had already attempted a series of designs from 'L'Allegro' and 'Il Penseroso', but they had been a failure. Valpy's request to be shown anything that affected his inner sympathies was just the stimulus Palmer needed to renew his enthusiasm for the Milton subjects.

The relationship between patron and artist is never an easy one, and Valpy was not the sort of man to allow Palmer a free hand. When the plan for a series of Milton subjects was first mooted, Valpy wrote to Palmer bombarding him with innumerable criticisms and suggestions. Palmer replied that he must keep his mind free of all preconceptions and that what mattered supremely was 'the vivid intensity of the mental "vision" that preceded the actual making of the design'.

Finally, in 1865, an arrangement was made for the production of eight drawings, each measuring 28 inches by 20 inches. At once Palmer began sketching out some of the designs which he described as lying photographed over his eyes, 'packed in their bone box ready for use'. As was his habit, he made the preliminary sketches in a very free, almost shorthand manner. These sketches were shown to Valpy, who approved, but not without another long correspondence in which he expressed his own ideas on how the subject should be done. This resulted in numerous points of disagreement, but in the end Valpy was wise enough to let Palmer have his own way.

Though the preliminary sketches were done with extreme rapidity, some of the designs coming to him, as Palmer says, 'unawares', the translation of these sketches into finished

(xviii) *The Lonely Tower. Engraving on steel*

drawings occupied Palmer for sixteen years and involved him, characteristically, in agonies of artistic conscience. How much he relied on the subtle processes of inspiration is revealed in the following extracts from letters written to Valpy in 1867 and 1870.

'While I was touching on the sheep in "The Lonely Tower", all of a sudden, I don't know why, the whole seemed to come as I intended, so I packed it up in a paper and string to make it difficult to get at, lest I should spoil it. In this state, a few breathings, after we have had a final look at it, will be precious.

'I am glad you are so indulgent as to give me a little more time, for I think some gossamer films and tenderness may be added, which are not always to be done at the proper time, but come strangely when one cannot account for it.'

In 1879 a major disagreement arose between Palmer and Valpy. According to A. H. Palmer, Valpy's attitude had now altered from pure enthusiasm for Art to that of a shrewd investor. In reply to a letter asking for a reduction in price, Palmer tells Valpy: 'I think you will feel that in the "L'Allegro" and "Il Penseroso" drawings, done in fact at half price, the commercial balance is vastly in your favour. I loved the subjects, and was willing to be the loser in all but the higher matters of Art and Friendship. I do not in the least complain that I have

(xix) *The Skylark. Engraving on steel*

lost a thousand pounds by them. It was my own act and deed. In the same time, I could have made thrice the number of telling and effective drawings of the same size, but I considered your taste and feeling so much above the ordinary standard that in order fully to satisfy them, I have *lavished time without limit or measure*, even after I myself considered the works complete.'

The tone of this letter must surely have pricked even the heardened conscience of an equity lawyer. The fact was that without the liberal settlement made by Linnell to each of his daughters Palmer could never have afforded the financial loss these drawings entailed. For him there was at least the consolation of making from the Milton subjects some of the most masterly etchings he ever did.

In the last years of his life etching became for Palmer the all-absorbing art. Of it he said: 'You are spared the dreadful death-grapple with colour which makes every earnest artist's liver a pathological curiosity.' Yet to bring etching to Palmer's standard of perfection involved death-grapples of a no less exacting kind. To acquire technical mastery by the arduous process of trial and error implies its crop of trials and disappointments, and in Palmer's case many of his etching failures were due to the incompetent printing of his plates by other hands. In the end a private press was set up at 'Furze Hill House', and thanks to the splendid skill that A. H. Palmer acquired in the use of it a new perfection of printing was achieved. On his own

63

part in this and what it meant to his father's etching practice, A. H. Palmer provides an illuminating note: 'On the advent of the first press, he had, for the first time, no need of an interpreter. For years I had seen the progress of his "blots", monochrome designs, and water-colour drawings. I had written down his views on art, and understood in detail the language in which he expressed them to himself and to an extremely limited audience. Constant surveillance of the printing on his part was therefore unnecessary.'

The last project of Palmer's life was a series of engravings based on subjects from Virgil's *Eclogues*. Though a number of the preliminary sketches were made, only one plate, 'Opening the Fold' had been completed when he died in May 1881.

Of all his dreams, the 'etching dream', as he called it, was in a sense the most rewarding, for it was in the medium of etching that he achieved a degree of public recognition which his other art had never won him. Though he detested 'Furze Hill House' and all it stood for, it was here with the devoted help and loyalty of his son that the 'etching dream' was so richly fulfilled. Of his son's unfailing loyalty there is evidence enough in all that he did in later years to establish his father's reputation, a loyalty which had in its selfless dedication something of Palmer's own unworldiness. It is fitting, then, that we should take leave of Palmer, the man, with the touching valediction written by his son.

'On the morning of the 24th of May my father asked for me, but I could only guess the meaning of the few words he whispered. This was our farewell and it was then, as I touched his hand for the last time, that I thought what he had been to me. Everything in the room (for he died in his study), had some memory of the hours we had spent together in years past—of all our little schemes and plots, and of the work he had done so devotedly. There, just behind me, were some of the ancient books he had loved in his youth, his plaster casts from the Antique, and his small models in clay or wax. Close by, in an old cigar-box which I had fitted with grooves, stood the Virgil plates, a commentary on the futility of human schemes. When I entered the room next, I found Mr Richmond reading some prayers by the bedside, in a voice broken by sorrow, and I knew that at last my father had left us.

'We chose his grave in one of the quietest parts of Reigate churchyard, and there we laid him on a warm, showery, spring morning of the very kind he loved most. Some elm-trees cast upon us his favourite "chequered shade", and just above us a skylark joyously sang till, as the last words of the service died away, it dropped silently into the long grass. Who could have wished a better requiem?'

II

When Samuel Palmer died in relative obscurity in 1881, who could have foreseen that this eccentric and unwordly Victorian would become in another fifty years a major influence in British art? Yet one of his contemporaries, Dante Gabriel Rossetti, writing in *The Spectator* two years after Palmer's death, did in fact foresee it and in a brilliant assessment of his powers made this claim for Palmer's art:

'Such a manifestation of spiritual force absolutely present—though not isolated, as in Blake—has certainly never been united with native landscape-power in the same degree as Palmer's works display; while, when his glorious colouring is abandoned for the practice of etching, the same exceptional unity of soul and sense appears again, with the same rare use of manipultive material. The possessors of his work have what *must* grow in influence, just

as the possessors of Blake's creations are beginning to find; but with Palmer the process must be more positive and infinitely more rapid, since, while a specially select artist to the few, he has a realistic side, on which he touches the many, more than Blake can ever do.'

This mention of Palmer's realistic side is an important reminder that if we are to understand him properly we must be prepared to see him whole. It has become so fashionable nowadays to write the epitaph of his art immediately after the Shoreham years that we are in danger of neglecting some of the most interesting and sensitive drawings of the English school. The temptation to oversimplify Palmer's case, to assume that after his marriage in 1837 and the wedding journey to Italy all the visionary qualities went out of him, has put a disproportionate emphasis on the Shoreham years. What happened afterwards was surely not so much a failure of vision as an attempt (tragically unsuccessful in terms of financial reward) to accommodate the vision to the bread-and-butter necessities of the material world.

No one, of course, can deny the importance of the Shoreham period or the richly imaginative art it produced. Palmer himself was always reverting to it, and his son records how often his father, in the cloistral seclusion of his untidy little study at 'Furze Hill House', would pore over the folios of Shoreham drawings to relive the golden dreams they conjured up. In a sense, the landscape of Italy, where Palmer and Hannah wandered for two penurious but happy years, was an extension of the pastoral world he had known at Shoreham—the aureate sunlight, the primitive havesting, the towered cities standing in romantic isolation on luminous skylines. The temptation to paint this landscape in the Shoreham manner must have been constantly present to Palmer, but for prudential reasons he resisted it. If we regret that he did, we must remember the particular circumstances in which he was placed. He was now a married man, a professional artist almost wholly dependent for a living on the sale of his work. To justify the expenses of the Italian journey, it had to be regarded as a form of investment, an opportunity for accumulating a stock of saleable material which might pay useful dividends in later years. Clearly these were Linnell's terms for sanctioning the visit, and in accepting them Palmer made it almost a point of conscience to tame his Italian vision to the kind of detailed and highly finished art that Linnell would approve. By this time Linnell's sympathy with the visionary work of Blake had all but disappeared, and his own growing professional success was largely due to an astute assessment of contemporary artistic taste. Vision, in the Blakean sense, was not, he realized, a marketable commodity, and he advises Palmer to concentrate his efforts on the highly finished exhibition pictures which may win him favour with the connoisseurs.

From Italy, Palmer wrote to Linnell describing his plans for making on his return to England 'little oil pictures and drawings painted in a day, at once from nature'. Linnell emphatically disapproved, pouring scorn on what he calls 'pot-boiling efforts' and 'cheap pennyworths of Art'.

When Palmer wrote again to Linnell two months later he made no mention of oil pictures and drawings painted 'in a day, at once from nature'. Instead, he makes a tactful reference to another plan . . . 'It appears important that, immediately on my return, I should begin one or two pictures of a moderate size ($\frac{3}{4}$ perhaps), which, *if successful*, would be likely to bring me into notice; and I am endeavouring at this moment to secure this point having just finished two most beautiful foreground subjects, which are at the same time highly poetical and full of the realization which connoisseurs look for.'

Palmer's journey to Italy has been called a disaster. It has been argued that it provided a surfeit of impressions that he was unable to digest and that the welter of Italian colour disturbed and vitiated his own colour sense. That Palmer's art did change after his Italian trip is partly true, but not for the reasons generally assumed. It was not the impact of Italy and its art that produced the change, but rather the circumstances in which Palmer found himself at this particular moment. Had he remained in England he would have faced, almost inevitably, the same crisis of confidence. For one thing he was no longer a free agent. Those letters written by Linnell made that abundantly clear, and the irascible despot issuing his orders and advice from remote Bayswater must have made Palmer uneasily aware that neither he nor Hannah would ever escape from that tyrannical control. Now for the first time he had to think of his art in terms of possible income, a situation very different from the old carefree Shoreham days. As A. H. Palmer says: '. . . Now the studies he had once pursued for their own sake had to be submitted to the touchstone of utility.'

His failure to find patrons for his work in Italy and the austerities and hardships he had experienced during his own years abroad must have brought home to him the desperate uncertainties of the artist's life. In Rome, in Naples, in Florence, the golden dream of Italy was dimmed for him by the thought of what he would have to face on his return to London —the long, perhaps unsuccessful, struggle for what he pathetically calls 'small monies'.

All these things had an inhibiting effect on Palmer. During the months he had spent in Rome on his arrival he had seen in the works of other men the kind of qualities which connoisseurs looked for. What pleased them was not imagination or poetic realism but a high degree of surface finish, combined with topographical accuracy. The only work that Palmer sold while he was in Italy was a drawing of this kind. In a sense this initial success was his undoing. It made him patron-minded at the start and almost everything he subsequently did in Italy was aimed at pleasing the taste of some hypothetical connoisseur. For this reason his Italian studies, with one or two beautiful exceptions, are among the least *personal* things he ever did.

In attempting a critical estimate of Palmer, it is best at the outset to dispose of this unsatisfactory phase of his art, so that his real achievement may be more appreciatively judged. If one considers the difficulties of his personal situation and the tempting rewards that compromise and mediocrity seemed to offer, it is all the more remarkable that in his middle years Palmer was able to regain those qualities of spontaneous seeing which during his Italian tour seem sometimes to have been irrecoverably lost.

Italy, one might say, came at the wrong period of his life. Had he gone there later, had he waited till the process of personal readjustment was more complete, he might have created in this Mediterranean world something comparable to the finest of his Shoreham work. As it is, Italy must be reckoned a disappointment. And the ill effects of it lasted well beyond his final return to England and that disenchanting plunge into the fog and darkness of a London winter. It was Italy, I think, and in particular the limited taste of Roman connoisseurs, that planted in Palmer's mind the idea of elaborate exhibition pictures, pictures in which finish and subject-matter were deliberately exploited for the sake of popular appeal.

With Shoreham and Italy behind him, Palmer had to make another start. On his return to England he had intended to become again a painter in oils, but some lack of inner confidence, or the rusting of his talent during the years abroad, made him incapable now of using

66

(xx) *View near Red Hill. Pen and ink*

the medium with any real effect. Palmer himself maintained that had he had at this stage the help and encouragement promised him he might have painted successfully from the figure, and so widened the scope of his art. It is with Linnell obviously in mind that A. H. Palmer writes: 'Deliberate promises of such help which had been made to him again and again were disregarded, and the golden dreams he had dreamed under the bright Italian noon faded away into the cold realities of a disappointed life.'

Here, not for the first time, A. H. Palmer underrates his father's powers of resilience. For the remainder of his life Palmer continued to paint in oils, though with varying degrees of success. On his return from Italy, one picture at least, 'The Rising of the Skylark', was painted with something of his old skill, and though finished at a later date, it suggests that this crisis in his oil painting was perhaps more psychological than real.

With Palmer's renewed interest in oil painting went a desire to take up again 'the thread of his Shoreham studies, and to pursue them with the great additional knowledge and experience he had gained in Italy'. What exactly Palmer had in mind, it is difficult to say. Probably he intended making his water-colour studies the basis of some larger and more elaborate versions in oils. Why did nothing come of it? It is difficult to believe that having once painted Shoreham subjects successfully in oils he could not, with a little practice, do so again. The success of his 'Skylark' painting, A. H. Palmer tells us, was due to the poetry of the subject. In fact, so deeply did it move Palmer that he forgot or overcame his doubts and hesitations in the medium of oils. And if the skylark subject, based on a sepia sketch of the Shoreham days, could move Palmer so deeply, how was it that the other Shoreham studies were not used in the same way? The answer is, I think, that after the painting of the 'Skylark', Palmer, for personal and other reasons, deliberately desisted in the experiment. It was not because he no longer cared about the Shoreham studies or had ceased to believe in them—probably they meant

more to him now than they had ever done—but because he realized that they belonged essentially to a vanished world. And for personal reasons he was anxious to dissociate himself from the state of mind those studies might seem to represent.

Looking at them today, we recognize their originality without finding them disturbingly eccentric. In the 1840s, with artistic conventions becoming more strictly codified, it was a different story. The eighteenth century just tolerated Blake, but the Victorians would certainly have been up in arms against him. As a reminder of how much things had changed since Palmer's youth, it is worth noting that between 1825 and 1835 twenty-seven of his Shoreham period works were exhibited at the Royal Academy. After 1841, with the exception of etching, no other work of his was hung, presumably because, even when he tried to paint conventionally, some oddness in the style made it unacceptable.[1]

For someone as unadaptable, or perhaps one should say as uncompromisingly original, as Palmer the chances of becoming a popular painter in the meagrely patronized field of landscape art were remote indeed. Even when he tried to adapt his style, his work remained so essentially individual that if accepted for exhibitions it was frequently hung in out-of-the-way corners lest its unconventional qualities contrasted too disturbingly with the more orthodox examples on the walls. Now it was the failure of his elaborate exhibition pictures that made him turn again to a simpler and more direct form of landscape art—that is, landscape directly recorded without recourse to stylization or imaginative treatment. 'When huffed by bad hanging,' he writes in a note, 'retreat for strength, not to popular style, but to nature.'

It was sound self-advice, and it is from these periodic retreats to nature, these arduous sketching tours undertaken with only a minimum of equipment and at beggarly expense, that the best art of Palmer's middle years derives. For the student of Palmer these journeys are not easy to date. Though he frequently inscribed his work with notes, and sometimes, like Constable, with the time of day, he tends to omit the year. In all probability it was in 1841 and not 1844, as A. H. Palmer states in *The Life and Letters*, that Palmer spent some time in Dorset, painting and teaching. Afterwards there were frequent tours in Devon, Cornwall and Wales, as well as weeks spent in places nearer London. Margate, for instance, was a favourite retreat and it was here in 1872 that he began working on his designs for Virgil's *Eclogues*. A. H. Palmer records that between 1848 and 1858 his father visited Devon and Cornwall at least four times, but he may also have been there a year or two earlier. For Palmer, Devonshire with what he calls its 'heaped-up richness' took the place of Kent as his ideal landscape, and in particular the country round Lynton and Lynmouth seems to have exerted on him an irresistible fascination.

From all these tours a great store of work was harvested. That so much of it goes unrecognized or is attributed to other hands, is probably due to the variety of its style. Sometimes, indeed, it bears resemblances to the work of Cox and De Wint, and even on occasions to the body-colour drawings of James Stark. In his efforts 'to abolish all niggle', as he calls it, Palmer abandons what one might term his pointilliste technique, the characteristic building up of his

[1] Palmer's experience at the Academy in 1841 was particularly unfortunate. Not only did he fail to sell a work, but he and Hannah lost their exhibition tickets. The idea occurred to Palmer that someone might find the tickets, endorse them and take possession of the pictures before he could clear them from the Academy. In a note to the porter there he directs 'that our works should *not* be given to anyone bringing our tickets'.

(xxi) *Cottage in Kent. Pencil* (*British Museum*)

colour surfaces by a process of stipple dots, and he adopts instead a style of broader washes and more naturalistic tones. He warns himself 'not to be solicitous about the brightness of little specks of light, so as to hinder the full sweep of a great brush by which should be attained the full and right effect at a distance'. And with this new freedom of brushwork he sometimes combines a strong and boldly hatched pencil line. In many instances broad washes of blue, sepia or green replace the favourite golds and yellows of the earlier drawings, and the liberal mixing of Chinese white with the basic colours gives these washes an almost pastel quality.

This change in Palmer's style reflects not so much a change in his mode of seeing as an attempt to give his art a more acceptable form. It is as if he is trying now to free himself from all those personal characteristics which he has come to associate with his public failure in the past. Yet however much he might wish to be more 'ordinary', he was too original an artist ever to conform. It is because he remained always so much himself that the art of his middle years was still, for all its variations, essentially personal. It may not be Shoreham art, but it is visionary in the sense that all Palmer's contacts with nature were in a way mystical experiences. He believed that by holding the mind in a state of receptivity the illuminating moment would come; and when he paints the cliffs of Cornwall or the Devon hills in his later years he still looks as he did at Shoreham, for the flash of inner vision. All his life, indeed, both in his art and in his religion, it is this intuitive light that he is always passionately and devoutly seeking, and wherever he finds it, as he himself confesses, he 'will turn to it like the sunflower'.

69

The 'realistic side' of Palmer, on which (to quote Rossetti again) 'he touches the many' has been, in fact, only appreciated by the very few. Overshadowed by the visionary and imaginative art of the Shoreham years, it has been taken as a proof of Palmer's waning powers. That seems to me the wrong way of looking at it. To use a chemical analogy, one might say that in Palmer's art Shoreham was the concentrate and what followed the by-products and derivatives, each different in their way, but having a basic affinity with the original substance. In other words, though in Palmer's later work Blake and Shoreham seem no longer the operative influences, they remain, in fact, an integral part of his sensibility, giving his art, even in its more conventional forms, a curiously personal quality. It is this difference that set him apart, that made his art generally unacceptable to the public of his day.

If one is tempted sometimes to wonder what sort of painter Palmer would have been if he had never met Blake, some clue is provided by the sketch-book recently acquired by the British Museum. Here we see Palmer at the age of fourteen working in a strictly naturalistic manner. A sky study in this book comes extraordinarily close to Constable and much of the pencil work might be taken as his. A debt to Constable at this stage is difficult to account for. There is a possibility that some artist acquaintance of Palmer's may have shown him sketches by Constable, but the more likely explanation is that they had certain influences in common, notably that of Girtin.

Without Blake, Palmer would probably have continued all his life to make Turner his guiding star, as he had done in the beginning. Though Turner's influence was largely superseded by the stronger impact of Blake, Palmer could never forget Turner's intoxicating colour and his mastery of atmospheric nuances. In some of Palmer's later work the influence of Turner reappears in the suffusing glow of sunsets and in the device of dramatizing light by concentrating it in areas of shadow. This use of light was frequently resorted to by Palmer when he painted what he called 'hollow compositions', as, for example, his large-scale water-colour 'The Dell of Comus'.

Palmer's admiration for Turner had begun when he first visited the Royal Academy in 1819 and stood entranced before Turner's 'The Orange Merchantman on the Bar'. It was a moment when the Turner spell might easily have overwhelmed him. It should be remembered that at this stage of his career Palmer possessed the kind of precocious talent which in a young and impressionable disciple can achieve miracles of emulation—as it later did when Palmer looked at Blake. But though he admired Turner profoundly, something in his nature craved a more muscular and substantial vision than the ethereal genius of Turner could supply. Probably his feelings for Turner were partially summed up in a note that he afterwards wrote about Cox.

'Cox is pretty—is sweet, but not grand, not profound. Carefully avoid getting into that style which is elegant and beautiful but too light and superficial; not learned enough—like Barret. He has a beautiful sentiment and it is derived from Nature; but Nature has properties which lie still deeper, and when they are brought out the picture must be most elaborate and full of matter even if only one subject be represented, yet it will be most simple of style, and be what would have pleased men in the early ages, when poetry was at its acme, and yet men lived in a simple, pastoral way.'

Here Palmer clearly knows the kind of art he is aspiring to. Yet in the years before this note was written he had suffered as an artist agonies of doubt and self-questioning. His early success, his very precociousness, was rooted in a spontaneous response to the beauty of

(xxii) *View from Richmond Hill. Pencil* (*British Museum*)

landscape. 'I distinctly remember,' he writes, 'that I felt the finest scenery and country in general with a very strong and pure feeling.' For a young and untaught artist this strong and pure feeling had carried him remarkably far. But when he began to think about art, when he began to concern himself with the problems of structure and technique, the early confidence and fluency vanished.

To quote his words again: '. . . when I gradually learnt arithmetic and grammar, my feeling and taste left me, but I was not then completely spoilt for art. But when I learned to paint a little, by the time I had practised for about five years I entirely lost all feeling for art, nor did I see the greatest beauties of even the Dutch masters, Cuyp, Ruysdael etc.; so that I not only learnt nothing in this space of time that related to high art, but I was nearly disqualified from ever learning to paint.'

The crisis that confronted him then was the realization that painting must be for him something more than an exercise of sensibility. Unlike most of his contemporaries, he was irresistibly attracted to the rigid discipline of form and line which had characterized the work of the early masters. 'The pit of modern art', as he calls it, was for him the temptation to reject such things and to accept instead the art forms of his time. It was the historical sense in Palmer, the innate feeling for the art and thought of earlier centuries, that put him at variance with himself and with the artistic creed of his day. What he sought was some synthesis that would reconcile his instinct for romantic art with the austere and formalized vision of the Middle Ages.

71

It was at this moment of lost inspiration and divided aims that Palmet met Linnell, a meeting that plucked him from the pit of modern art, but left him still confused and faltering on the brink. 'After struggling to get out for the space of a year and a half, I have just enough cleared my eyes from the slime of the pit to see what a miserable state I am now in . . . I have now made my first struggle—alas, with how little success. I shall now begin a new sketch-book, and I hope, try to work with a child's simple feeling and with the industry of humility.'

To the bewildered youth Linnell had given the momentous advice: 'Look at Albert Dürer.' But he had also taken the more momentous step of introducing him to Blake. Palmer's hope that he might 'work with a child's simple feeling and with the industry of humility' was no doubt the fruit of Blake's own example and it was a guarantee on Palmer's side that he had reached that state of mind in which true discipleship could profitably begin. In bringing Palmer and Blake together Linnell had opened, without knowing it, one of the most fascinating chapters in English art.

One would give a great deal to know what Blake thought of Palmer as a person and what the two men discussed on the long walks they took from Broad Street to Linnell's home at Hampstead. If A. H. Palmer knew these things, he is tantalizingly reticent on the subject. In reading the *Life and Letters*, one feels that Blake was considered for various reasons dangerous ground. A. H. Palmer tends to conventionalize him, as Palmer himself does in later years. Palmer, for instance, stresses his industrious nature, his earnestness and the essential sanity of his mind. He emphasizes Blake's adherence to Christianity and tells us that he never heard Blake praise the American Constitution. For his own personal reasons and in deference to Victorian opinion, Palmer obviously believes in playing Blake 'safe'.

Yet for someone as close to Blake as Palmer was, how much more he might have said about the greatest man he had ever known, 'a man without a mask', as Palmer so brilliantly described him. If Palmer chose to be guarded on the subject, it was almost certainly because he was convinced that Blake would be completely misunderstood by 'that led lion the British public', as Palmer calls it, just as he was equally convinced that anything resembling his old Shoreham style of art would be dismissed as lunacy.

That Blake approved of Palmer's aims in art is obvious enough. At their first meeting in Fountains Court he seems at the outset to have accepted Palmer as a kindred soul and to have gone out of his way to give the young artist encouragement and advice. If Blake made Palmer his confidant, as he surely must have done, it is surprising how little Palmer tells us of his views and conversations. Probably Palmer realized that merely to report Blake would be to maim him and that only those who had known him personally could resolve for themselves those paradoxes and contradictions which were used by Blake to give, so to speak, a keener edge to truth.

Palmer's concern for Victorian susceptibilities is shown in the advice he gives to Mrs Gilcrist on the preparation of her husband's book on Blake. In a letter written to her in 1862 he suggests that parts of Blake's own text should be omitted. 'I should let no passage appear in which the word Bible, or those of the persons of the blessed Trinity, or the Messiah were irreverently connected.'

And he goes on to say that 'it would explain matters somewhat if the public knew that Blake sometimes wrote under irritation. Nothing would explain some things in the MS. Being irritated by the exclusively scientific talk at a friend's house, which talk had turned on the

(xxiii) *Sky Study. Water-colour* (*British Museum*)

vastness of space, he cried out, "It is false. I walked the other evening to the end of the earth, and touched the sky with my finger." '

As Palmer quotes it, this seems intended to exemplify one of those aspects of Blake which 'nothing could explain'. Yet knowing Blake as Palmer did, he must have understood the workings of Blake's mind, must have realized that Blake's outburst was his way of stressing something that seemed to him of greater consequence than the scientific pronouncements of his friend. What he is saying in effect is that the powers of human imagination are more impressive to him than the vastness of space. In imagination he can walk to the end of the earth and touch the sky with his finger—a palpable falsehood in the factual sense, but 'truer' for Blake than anything scientifically measured or explained. This is the essence of Blake's philosophy, his belief that the real centre of knowledge is the inner consciousness rather than the mind.

In this respect he is again extraordinarily close to D. H. Lawrence in our own century, who shared Blake's distrust of purely scientific evidence. A case in point is Lawrence's disbelief in the theory of evolution. When reminded of the overwhelming evidence in its favour, he replied: 'But I don't care about evidence. Evidence doesn't mean anything to me. I don't feel it here.' (and he pressed his two hands on his solar plexus.)[1]

Another thing that Blake and Lawrence had in common was an unshrinking acceptance of the body, an acceptance that stemmed from their belief in the essentially religious nature of the sexual experience. Probably Blake would have gone a long way in accepting Lawrence's

[1] Aldous Huxley, in his preface to *The Letters of D. H. Lawrence.*

later theories that the vital centres of the body could be interpreted in terms of a vaster cosmic pattern and that man's instinctive consciousness was a residual part of some primal knowledge greater than the mind.[1]

Rejecting the theory of evolution as completely as Lawrence did, Palmer believed, like Blake, that the human form was a divinely created thing. Writing from Pozzuoli in 1838, Palmer offers this advice to his cousin Albert, who was then displaying an interest in art. 'If you go on drawing, continue to study from the divine, eternal, naked form of man, even if you are driven out from the society of men, and obliged to pursue your studies in a hay-loft . . . The devout and holy study of the naked form purifies the imagination and affections, and makes us less pervious to evil temptation. Here, beauty is often the whited sepulchre of vice; but in eternity that human form is, as it were, the body and symbol of goodness and truth. Seas may forsake their channels, mountains be shaken to their base, but the eternal form of man will survive the wreck, and, as it existed from eternity in the Divine Idea, will flourish in immortal youth amid the "clash of worlds".'

The Palmer writing here is certainly far removed from the free-thinker he confessed himself as having been at the age of fourteen. The change in him had come long before his meeting with Blake, but it was his contact with Blake that finally produced in him the creative fusion of the artistic and religious experience. In different ways both Palmer and Blake were symbolists, but with Palmer the symbolism tends to be more subtle and less easily recognized. In Blake's case the poet and painter were uniquely combined, though it is the literary side of him that frequently predominates. When he painted it was the poet in him that conjured up the imagery and on this account the symbolism is more literary, more consciously applied, than Palmer's is. In Palmer's early work, particularly in the Shoreham period, the deeper levels of consciousness come into play with a freedom that is astoundingly modern, and his almost obsessive use of yellow might be taken to exemplify the quality of spiritual warmth which Kandinsky ascribes to it. To say that Palmer's predilection for the shapes of moons and towers is a form of sexual symbolism is only true if one divests that symbolism of its Freudian limitations. For Palmer, as for Blake, man's physical nature was only a constituent part of the spiritual spectrum, and to explain him in purely biological terms would be to deny him the capacity for what Blake calls 'Spiritual Sensation'. For Blake, 'spiritual sensation', 'poetic inspiration', 'imagination' were all synonymous terms for the spiritual essence that he discerned beyond the material world. Though Palmer shared Blake's awareness of this essence, his feeling for nature made him instinctively express his vision of it in landscape form, thus differing from Blake, who found little to inspire him in what he contemptuously calls 'the vegetative world'. 'Natural Objects', he once wrote, 'always did and now do weaken, deaden and obliterate imagination in Me.'

For someone as preoccupied with spiritual presences as Blake was, this view is perhaps understandable, but if Palmer appears in contrast more earthy it is because his imagination was of a different order.

Blake claimed on occasions to be possessed of a 'a fourfold vision' and, in less exalted moments, of a 'twofold' one. Though Palmer never defined his degree of vision in quite these terms, one might say that measured in the Blakean scale, it was essentially of a twofold kind,

[1] For Lawrence's views on this see his *Apocalypse*. Also Frederick Carter's essay *D. H. Lawrence and the Body Mystical*.

that is he saw the physical world as co-existent with an ideal reality which manifested itself in the powers of the imagination. In his Shoreham days at least he would have accepted unequivocally Blake's assertion that . . . 'To the Eyes of the Man of Imagination, Nature is Imagination itself'.

In all these ways Palmer is very close to Blake, yet in reading the letters about him which Palmer wrote to Mrs Gilcrist in 1862 one has the feeling that the intervening years brought some cooling of enthusiasm. It is, I think, an impression that Palmer deliberately tries to give, and if one remembers how shocking to Victorian ears many of Blake's sayings must have been, this caution on Palmer's part is understandable. Yet Blake, in fact, never ceased to fascinate him. Writing to L. R. Valpy in 1864, Palmer says:

'Mrs Palmer and I spent an evening with Mr and Mrs Gilcrist, looking over a number of Blake's drawings; and were so rivetted and unaware of time that a first look at the watch told three in the morning! Our servants were frightened! As we are early people, they thought we must have been slain and disposed of in a ditch.'

If Palmer had been a more worldly person, he might have thought that Blake's ideals had little relevance in an age that had so patently outgrown them. In the case of George Richmond, though he paid lip-service to Blake's memory, his discipleship was never more than transitory and he bluntly told Palmer that his years at Shoreham had been a waste of time. To have remained Blake's follower required a quality of unworldliness that was not in Richmond's character nor in Linnell's. Innocence, as Blake and Palmer possessed it, was not an incapacity for experience, but an incorruptibility of vision that transcended it. To see as a child is not necessarily to think as one, and both Blake and Palmer were men of impressive mind. What they refused to do was to accept the intellect as the supreme source of knowledge, believing that to do so would be death to the senses. Blake is explicit on this point, and throughout his writings he rails against the rationalists, the men like Locke and Newton who embody for him the deadly 'single vision' which, in rejecting mystery and intuition, destroys all the richness and spontaneity of life.

There is something splendid in Blake's crusade for mystery, and whether we agree with him or not, we cannot but admire the passionate sincerity with which he preached. Mystery, then, as something apprehended by the imagination, was central to Blake's life and art. Hence his obsessional interest in the remote past, in Druid legend and the world of Old Testament history. Yet it was history of a relatively modern kind that made him the particular kind of artist that he was. As a young man he had drawn the Gothic monuments in Westminster Abbey, and the experience was one that he never forget. To an artist of lesser sensibility it might have been merely an exercise in copying, but to Blake it opened the mind to the intoxicating splendours of the Gothic world. To work there in the shadowy magnificence of the Gothic building, with its richness of stained glass and its intricacy of carving, was to live again in the spiritual climate that had inspired it. For the rest of his life, one might say, Blake was haunted by the mystery of the Gothic fold, and the memory of the sculptured figure was always present in his own drawing of the human form. Richness, intricacy, robust vision— these were things the Middle Ages bequeathed to Blake, and to think in terms of jewelled surfaces became for him the natural way of painting.

To the youthful Palmer, Blake's richness and colour came as an overwhelming revelation. In one of his sketch-books he writes: 'I sat down with Mr Blake's Thornton's *Virgil* woodcuts

before me, thinking to give to their merits my feeble testimony. I happened first to think of their sentiment. They are visions of little dells, and nooks, and corners of Paradise; models of the exquisitest pitch of intense poetry. I thought of their light and shade, and looking upon them I found no word to describe it. Intense depth, solemnity, and vivid brilliancy only coldly and partially describe them. There is in all such a mystic and dreamy glimmer as penetrates and kindles the inmost soul, and gives complete and unreserved delight, unlike the gaudy daylight of this world. They are like all that wonderful artist's works the drawing aside of the fleshly curtain, and the glimpse which all the most holy, studious saints and sages have enjoyed, of that rest which remaineth to the people of God. The figures of Mr Blake have that intense, soul-evidencing attitude and action, and that elastic, nervous spring which belongs to uncaged immortal spirits. . . . Excess is the essential vivifying spirit, vital spark, embalming spice . . . of the finest art. Be ever saying to yourself "Labour after the excess of excellence" . . . There are many mediums in the *means*—none, O, not a jot, not a shadow of a jot, in the *end* of great art. In a picture whose merit is to be excessively brilliant, it can't be too brilliant; but individual tints may be too brilliant. We must not begin with medium, but think always on excess, and only use medium to make excess more abundantly excessive.'

It was characteristic of Palmer to note in Blake 'a mystic and dreamy glimmer as penetrates and kindles the inmost soul'. For Palmer colour could be as evocative of mystery as twilight and darkness were. This is, I think, because he tended to see colour not directly but as a kind of illuminated shadow. It should be remembered that much of Palmer's painting, especially in his later years, was done by lamplight and was intended to be seen in partially lighted rooms. This probably explains why so many of his later water-colours seem in the full light of day so harshly bright. But if we think of them as intended, like stained glass, to throw their colour into areas of receptive shadow, how different they become.

The mystic and dreamy glimmer that moved Palmer so deeply in those *Virgil* woodcuts was really more characteristic of his own work than it was of Blake's. All his life he was fascinated by the shadowy world of twilight and nightfall. Possibly this feeling went back to his earliest boyhood when, as a motherless child, his loneliness was partly soothed away by the comforting glow of lamplight and by the bedtime attentions of his nurse, the faithful Mary Ward, 'who', as Palmer says, 'with little education else, was ripe in that without which so much is often useless or mischievous: she was deeply read in her Bible and *Paradise Lost*'.

Not only did she give him the affection he needed, but she also helped to form his literary taste. Writing about her, Palmer says in later life: 'A Tonson's Milton, which I cherish to this day, was her present. When less than four years old, as I was standing with her, watching the shadows on the wall from the branches of an elm behind which the moon had risen, she transferred and fixed the fleeting image in my memory by repeating the couplet:

> Vain man, the vision of a moment made,
> Dream of a dream and shadow of a shade.
> (Edward Young, *Paraphrase of Job*)

I never forgot those shadows, and am often trying to paint them.'

In the mystery of shadow Palmer seems to have found a symbol of those spiritual intimations that were not to be experienced in the gaudy daylight of this world.

It is easy to understand how Palmer came to develop 'a passionate love—the expression is

not too strong—for the traditions and monuments of the Church; its cloistered Abbeys, Cathedrals and Ministers, which I was always imagining and trying to draw'.

The Baptist religion in which he had been brought up lacked the beauty of ritual and tradition which for him was an enriching element of faith. The bare, neat chapel, for all its sincerity and high principles, was too near the modern world to satisfy Palmer's historical sense. He wanted worship of an older kind, and the famous lines from Milton's *Il Penseroso* must have echoed his own instinctive feeling for the ritual and architecture of the established Church.

> 'But let my due feet never fail
> To walk the studious Cloysters pale,
> And love the high embowèd Roof
> With antick Pillars massy proof,
> And storied Windows richly dight,
> Casting a dimm religious light.'

In turning to the Church of England he was reverting to the family tradition, for ancestors of his had been Anglican clergy in the distant past. As Palmer himself said, 'it was in the blood'.

It was this traditionalism in him that laid him open in later years to accusations of hypocrisy and secret Papist learnings. Of all his collisions with Linnell, the issue of religion was the most divisive and the most disastrous. Linnell at different times of his life and tried many forms of religion and found none to his liking. Basically, it was his hatred of conformity that made him intolerant of anything that seemed to smack of orthodoxy in other men, and his insistence that Hannah and Palmer should be married in a registry office was the beginning of a lifelong attempt to deny them any freedom of religious view. History gives us an ironic glimpse of Linnell in his old age, Bible in hand, adjuring Holman Hunt to assure himself of his eternal salvation.

To Palmer, unwisely housed on Linnell's doorstep, the idea of asserting his independence seems to have vanished at the start. Personal grief and professional disappointment made him drift into a state of acquiescence, and, unlike Blake, he became in his final years a man sheltering behind a mask. What he felt about himself is revealed in a comment added much later to some notes he had made at Shoreham in a copy of Payne Knight's *Analytical Inquiry into the Principles of Taste*.

'I knew the positive and eccentric young man who wrote the notes in these pages. He believed in art (however foolishly); he believed in men (as he read of them in books). He spent years in hard study and reading and wished to do good with his knowledge. He thought also it might with unwavering industry help towards an honest maintenance. He has now lived to find out his mistake. He is living somewhere in the environs of London, old, and neglected, isolated—laughing at the delusion under which he trimmed the midnight lamp and cherished the romance of the good and beautiful; except so far as that, for their *own sake*, he values them above choice gold. He has learned however not to "throw pearls to hogs", and appears, I believe, in company, only a poor, good-natured fellow fond of a harmless jest.'

For Palmer, who belonged so essentially to the old order of things, what was there left in a changed and changing world? Surely not much that he really cared about or valued. Contemporary society might consider itself on the march, but as far as Palmer was concerned it was

marching backwards with colours flying. He was in the last years of his life like a man living in a house from which all his most precious possessions were being stolen one by one. Yet something still remained. There were the weeds so carefully tended in the garden, the still unspoiled view towards Leith Hill, the orange twilight, the star points glinting through the boughs of trees. And there was that recurrent symbol of so much of Palmer's work—the full or quartered moon: not the great moon that had once brooded over the valley at Shoreham, but, as Palmer maintained, a smaller modern moon, gleaming palely over the stucco villas and the railway lines at Red Hill. Time that had stolen so much of his world had left him at least that symbol. For Palmer in his little study at Furze Hill House it may have brought that philosophic consolation which a Japanese poet had summed up so briefly many years before:

'The thief
Left it behind—
The moon at the window.'[1]

[1] The Soto Zen monk, Ryokan (1758–1831).

THE COLOUR PLATES

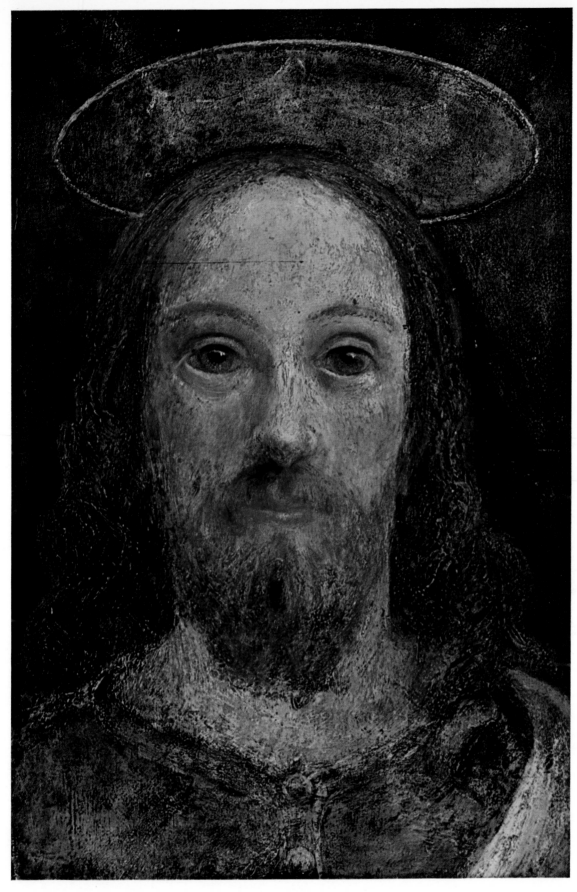

1 Self-portrait of the Artist with Aureole. Oil

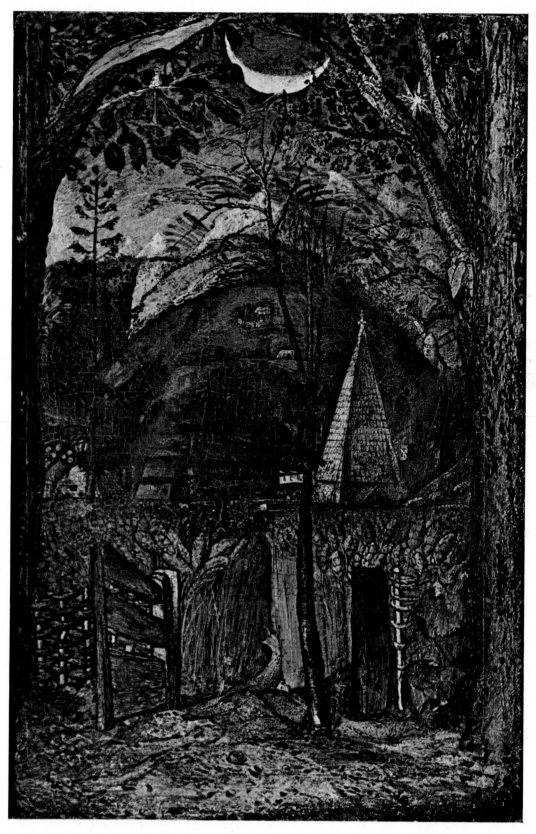

2 Hilly scene with Church and Moon. Tempera, water-colour and pen

(Tate Gallery, London)

3 The Magic Apple Tree. Water-colour and pen
 (Fitzwilliam Museum, Cambridge. Reproduced by permission of the Syndics)

4 Pastoral with Horse-chestnut. Water-colour *(Ashmolean Museum, Oxford)*

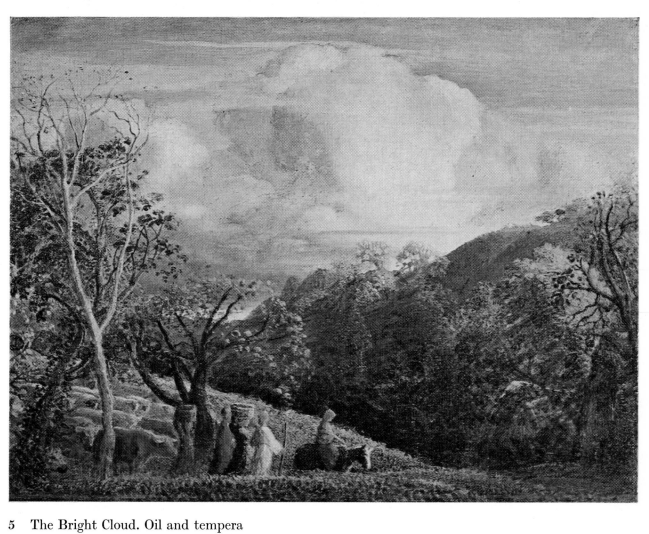

5 The Bright Cloud. Oil and tempera

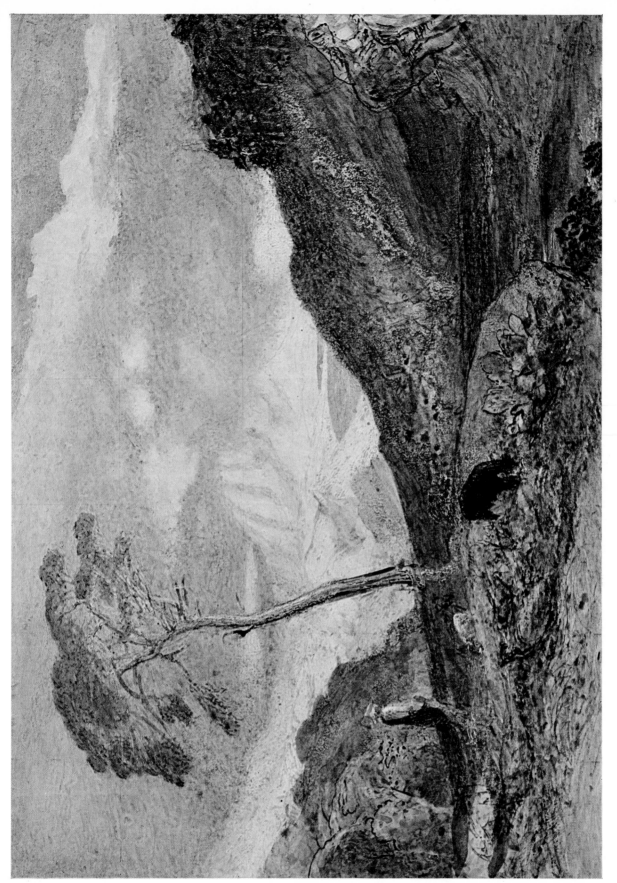

6 · The Goatherd. Water-colour

7 View at Tivoli. Water-colour

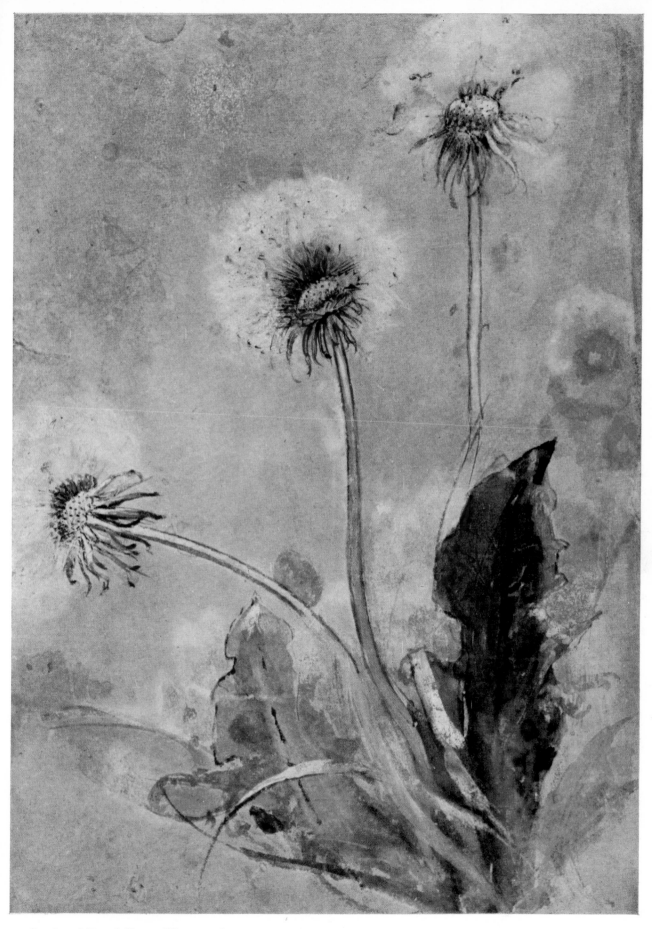

8 Study of Dandelions. Water-colour

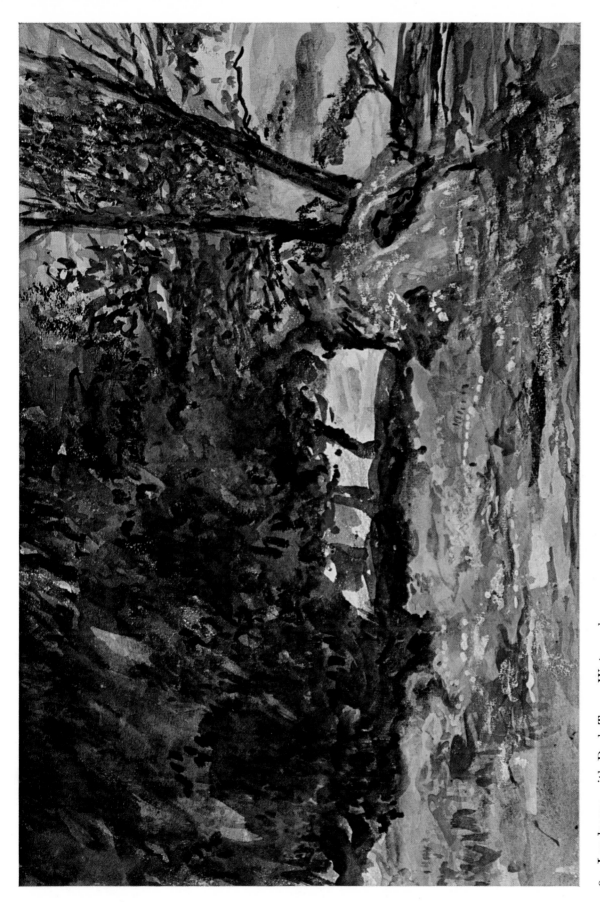

9 Landscape with Dark Trees. Water-colour

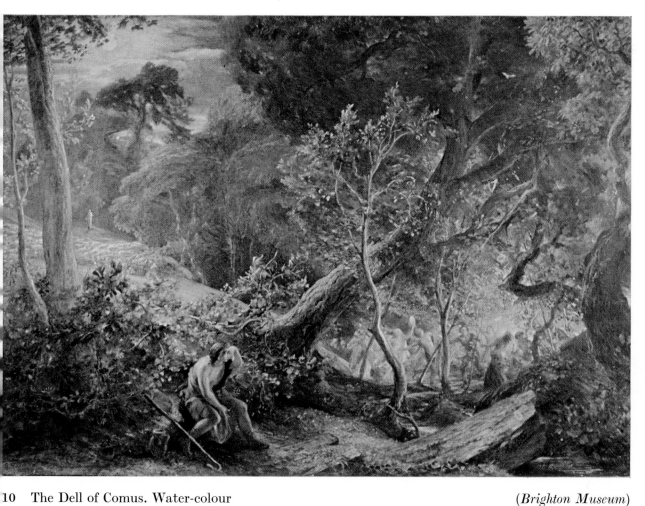

10　The Dell of Comus. Water-colour　　　　　　　　　　　　　(*Brighton Museum*)

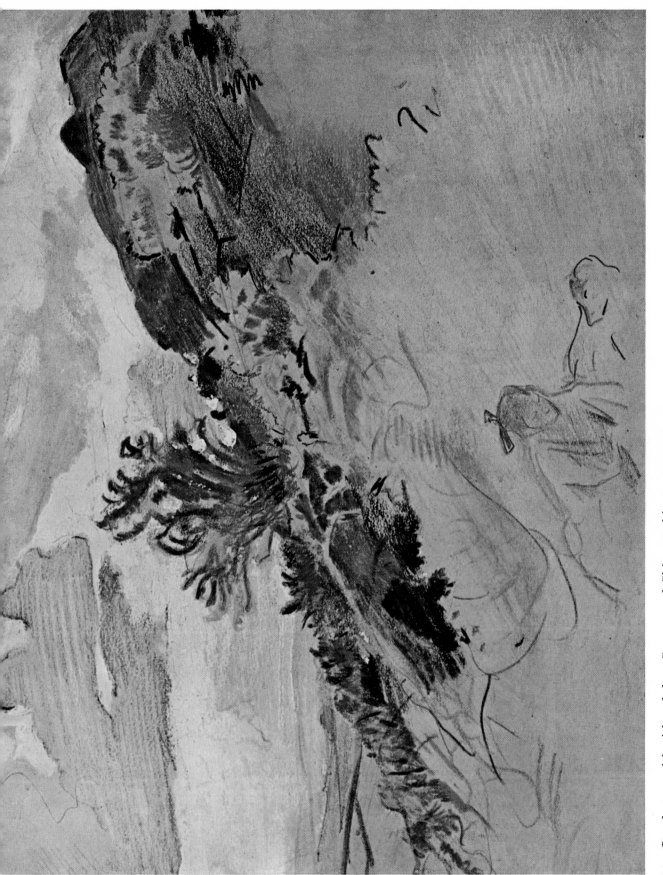

11 Landscape with girl and dog. Crayon and Chinese white

THE MONOCHROME PLATES

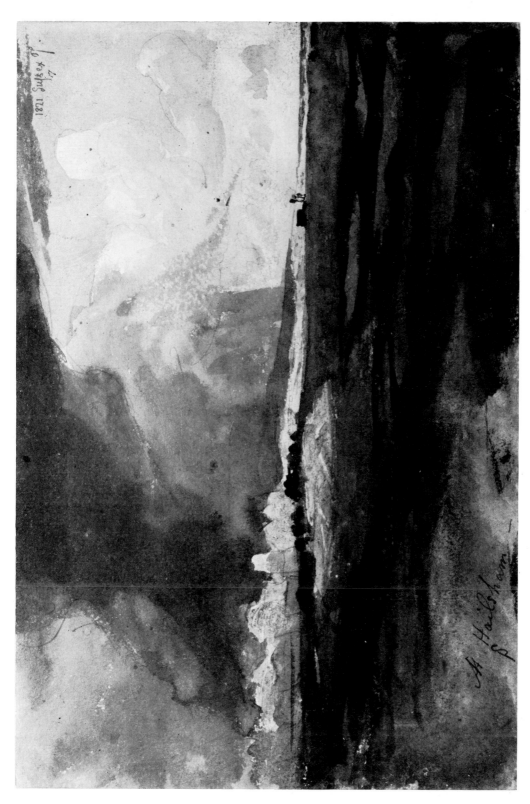

1 Hailsham, Sussex: Storm Effect. Water-colour

2 Barn in a valley (Sepham Farm). Pen and brush in Indian ink over pencil (*Ashmolean Museum, Oxford*)

3 Oak Trees in Lullingstone Park, Kent. Pen and ink, and water-colour

(*National Gallery of Canada*)

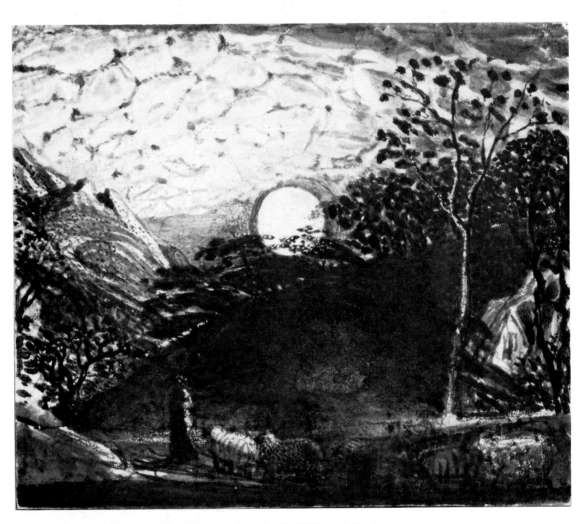

4 A Shepherd leading his Flock under the Full Moon. Sepia

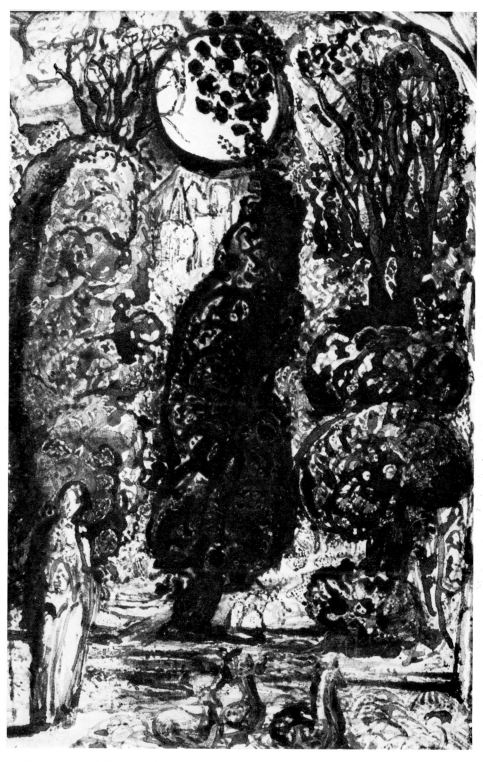

5 Woman and Deer under a Full Moon. Body colour and sepia wash
(Victoria and Albert Museum: Crown Copyright)

6 Tintern Abbey. Pencil heightened with body colour

7 View at Linton, Devon. Pencil and water-colour

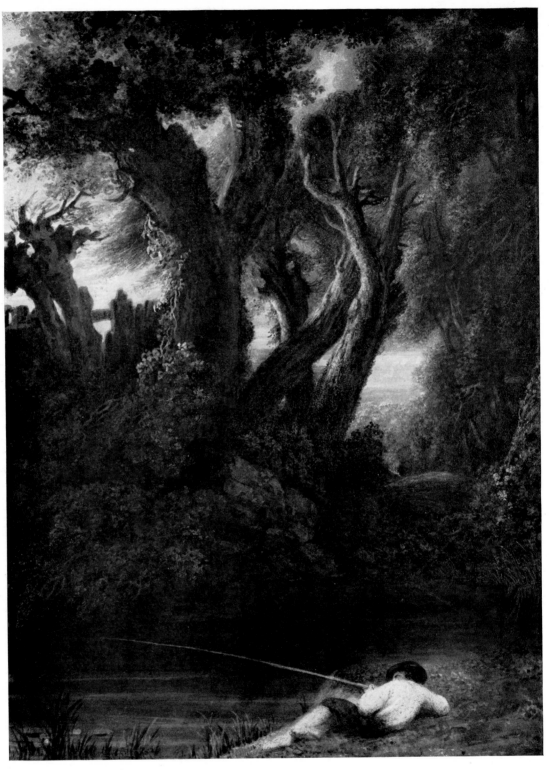

8 The Young Angler. Water-colour (*National Gallery of Canada*)

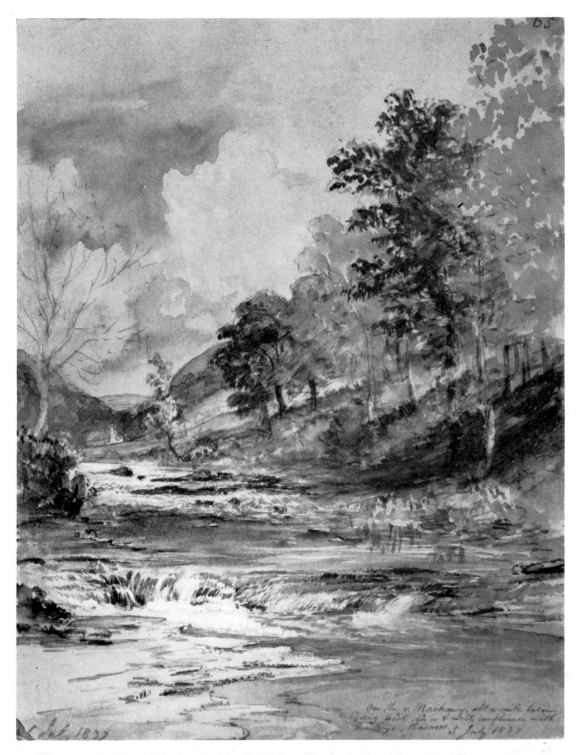

On the r. Machawy, abt a mile below
Craig pwll dû — & abt it's confluence with
the Wye, Radnor. 5 July 1837

July 1837

9 View on the River Machawy, North Wales. Black chalk and water-colour

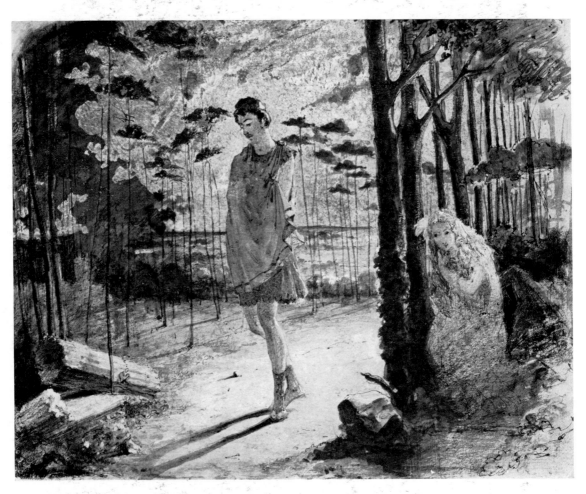

10 Classical Subject. Water-colour

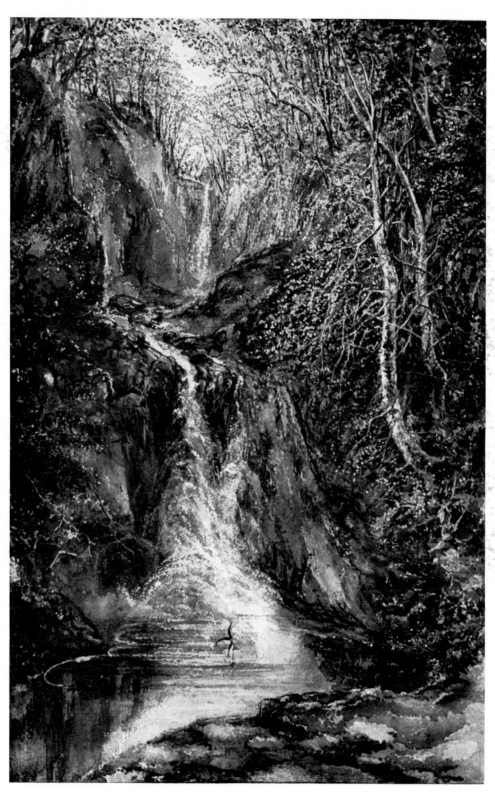

11 Pistyll Rhaiadr, North Wales. Water-colour

12 View from the Villa D'Este, Tivoli. Water-colour

13 Lulworth Cove, Dorset. Pencil and water-colour

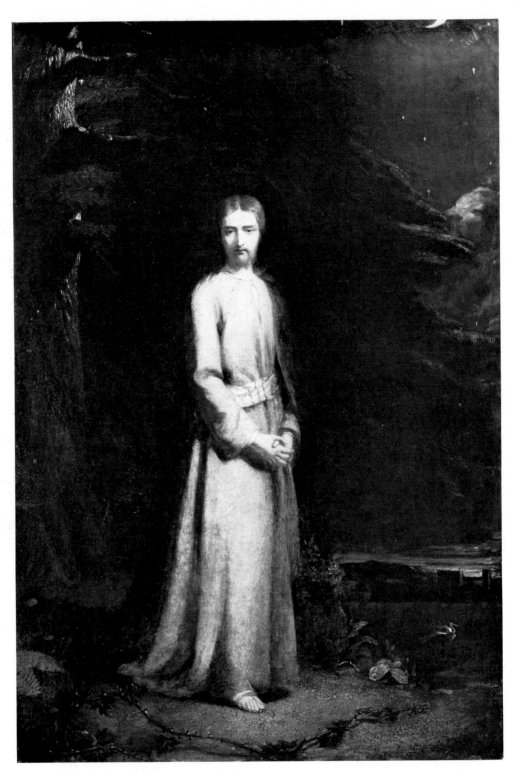

14 Christ outside Jerusalem. Oil

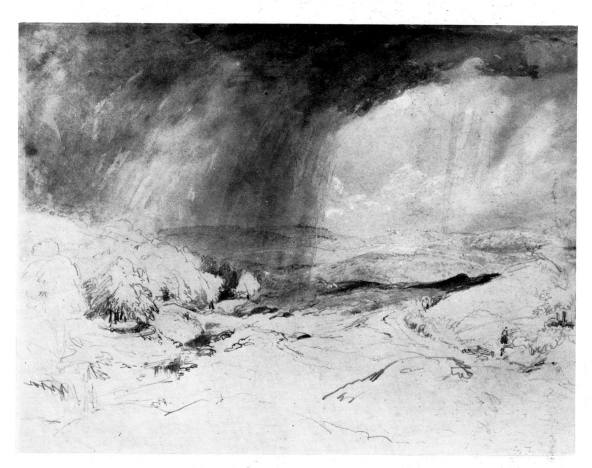

15 Landscape with Rain-cloud. Pencil and water-colour

16 Coast at Lynmouth, Devon. Pencil and water-colour

17 Study of Waves breaking on the Sea-shore. Pencil

(*National Gallery of Canada*)

18 Tintagel Castle: Approaching Rain. Pencil and water-colour (*Ashmolean Museum, Oxford*)

19 Truro River. Pencil and water-colour

20 Cascade in Shadow. Pencil and water-colour

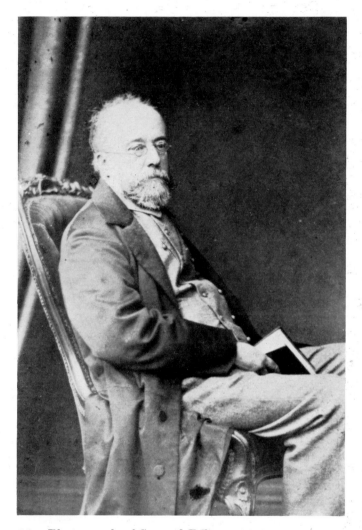

21 Photograph of Samuel Palmer, 1863

22 Wooded Landscape with Stream. Water-colour

23 The Brothers under the Vine. Water-colour

(*Victoria and Albert Museum: Crown Copyright*)

24 The Eastern Gate. Sepia wash

Notes on Illustrations in Text

i Study of a Cat. Indian ink, with smaller studies in pencil. $4\frac{9}{16} \times 7\frac{7}{16}$ in. Page from a sketch-book of 1824. Numbered by the artist '52'. British Museum.
The inscription in ink at the bottom of the drawing refers to figure studies of the three Maries at Christ's tomb on the opposite page.

ii Landscape Study with Crescent Moon. Indian ink. $4\frac{9}{16} \times 7\frac{7}{16}$ in. Page from the 1824 sketch-book, numbered by Palmer '57'. British Museum.
This study typifies in embryo the rich, arabesque quality of Palmer's Shoreham art.

iii God creating the Firmament. Indian ink. $4\frac{9}{16} \times 7\frac{7}{16}$ in. Page from the 1824 sketch-book numbered by Palmer '61'. British Museum.
One of the individual studies for a proposed series of religious pictures which were to be incorporated in a large, formal design. On one of the pages of the 1824 sketch-book Palmer has drawn a rough plan of this design which seems to have been conceived as an altar setting with appropriate architectural features (statues of St Peter and St Paul are included) to provide a Gothic framework for the pictures. Basically the design consists of a squarish central picture, with four oblong panel paintings placed in pairs longitudinally on either side. The drawing illustrated here is a design for a painting in a pair of panels depicting the Creation. In the plan sketched out by Palmer he has written under a rough, thumb-nail version of this design, 'He made great lights'—presumably a misquotation of a line from Psalm 136: 'Who hath made great lights'.

iv Two Studies of a Girl's Head. Indian ink. $4\frac{9}{16} \times 7\frac{7}{16}$ in. Page from the 1824 sketch-book numbered by the artist '91'. British Museum.
In a note on an earlier page of the sketch-book Palmer records in characteristic detail the experience that inspired these drawings: 'I saw in my spec. glass the most wonderful miniature which note I well nor heedless let it slip. In it these 3 textures struck upon the eye instantly. 1st the firm enamel of a beautiful young face, with 2nd going down from the forehead smooth and unbroken over the shoulders, Hair, wondrous sleek, and silkily melting (in long hairs more thin than man can do) into 3rd, a background of the crisp mosaic of various leaved young trees thinnishly inlaid on the smooth sky—so that there was an extreme soft between two kinds of hards. . . .'
In Palmer's final analysis the 'soft' of the girls's 'silky hair' forms the intermediate contrast between the 'hard' of her 'enamel face' as he calls it and the 'hard' of the jewels on the oaks in the background.

v Ruins on a River-bank. Pen and sepia. $11\frac{1}{8} \times 7$ in. Probably early Shoreham period. This drawing has affinities with another sepia drawing by Palmer, 'The Haunted Stream'. Collection: William Abercrombie.

vi Landscape with Figure embracing a Tree Trunk. Pencil and wash. 6 × 4 in. Shoreham period. Spooner Collection.

vii The Cyder Feast by Edward Calvert. Wood-engraving. $5\frac{1}{2}$ × 3 in. 1828. Of this design, Palmer wrote to Calvert: 'I don't set up for a judge, but, like a blind baby feeling for the breast, know the taste of milk, with a somewhat precocious appetite for cream. I find the cream in your *Cider Press*, which, in poetic richness, beats anything I know, ancient and modern.' Collection: David Dulley.

viii Stream with Overhanging Trees. Sepia pen line, with grey wash foliage. $9\frac{3}{4}$ × $7\frac{1}{2}$ in. Early Shoreham period. Private collection.

ix A Wooded River-bank. Pencil $8\frac{1}{2}$ × $6\frac{3}{8}$ in. Probably drawn on the banks of the Darent, near Shoreham, about 1829. Collection: Charles Emmanuel.

x A Church, with a bridge and a Boat. Brush and brown ink. $4\frac{1}{2}$ × $3\frac{5}{8}$ in. About 1832. Ashmolean Museum, Oxford.

xi View at Lydford, Devon. Pen and brown ink. Size of paper $7\frac{1}{2}$ × $3\frac{3}{8}$ in. Inscribed in the artist's hand at top right: 'Wednesday Oct. 3 1832'. And below: 'Lidford [*sic*] Church and Tower as it appears from the road going down to the Falls'.
On the back of the paper is another inscription which in the illustration has been transferred to the front of the drawing and is shown as an extension of the bottom edge. The writing here is made problematical by two abbreviations towards the end of the line, but the first nine words clearly read: 'Round of Cornish visits on the 21st and this—' The abbreviation that follows is probably the shortening of the word 'from' to 'frm', and the next abbreviation which seems to read 'wrng'—the g separated from the first three letters and written horizontally—is perhaps a shortening of the place-name Werrington, a village on the Devon-Cornwall border, not far from Lydford. The final word which seems at first sight to be 'every' might be read more logically as 'early'. Thus the whole line could read: 'Round of Cornish visits on the 21st and this from Werrington early'. Private collection.

xii View of the River Lyn, Devon. Pencil. $7\frac{1}{2}$ × 5 in. Probably 1832 or 1835. Inscribed by Palmer: 'From the back of Glenlyn; looking up the River Lynn'. Collection: Miss C. Douglas.

xiii View at Lynmouth (?). Pen and black ink. 9 × $7\frac{1}{2}$ in. Probably 1832 or 1835. Inscribed by Palmer: 'From my bedroom window. Myrtles in full blow'. Collection: Miss C. Douglas.

xiv A Devonshire Cottage. Pen and ink. $7\frac{1}{2}$ × $5\frac{7}{8}$ in. 1832 or 1835. Inscribed by the artist: 'A Devonshire Cottage'. Private collection.

xv Portrait of Samuel Palmer by George Richmond. Pencil. $8\frac{1}{2} \times 6\frac{1}{4}$ in. Drawn about 1835. Author's collection.

xvi Pastoral Scene. Black chalk on buff paper, with washes of gamboge, heightened with white and lightish yellow. $16\frac{1}{2} \times 9\frac{5}{8}$ in. One of a series of three pastoral 'variations' in which Palmer has made experiments in composition. In the two other drawings a shepherd has been introduced and the general grouping changed. About 1844–5. Private collection.

xvii Coast Scene, with Passing Rain. Grey wash with black and white chalk on grey paper. $7\frac{5}{8} \times 10\frac{7}{8}$ in. Inscribed by Palmer: '1 o cl. Noon 15 mins. after the last squall (?) past'. On the back of this drawing is a sea study with a rough sketch of a building on a distant shore. Probably a study on the Devon or Cornish coast, about 1848. Author's collection.

xviii The Lonely Tower. Engraving on steel. $7\frac{1}{2} \times 9\frac{15}{16}$ in. Published state. Completed in 1879. One of the plates for *Il Penseroso*, published for the Etching Club by R. Ansdell in 1880. Numbered '16' in lower left-hand corner. Signed 'Samuel Palmer'.
I am grateful to Mr Edward Malins for pointing out that the subject of this etching is an idealized view of Lee Abbey, Devon. Of this plate Palmer wrote: 'I love it though it has quite smashed me by the way my *Lonely Tower* has been printed. Full directions were sent to the printer, and a model proof, but in vain.' Collection: David Dulley.

xix The Skylark. Engraving on steel. $4\frac{11}{16} \times 3\frac{7}{8}$ in. 1850. Published state. Published as Plate 17 of *Etchings for the Art Union of London by the Etching Club*, 1875. Signed 'S. Palmer'. Lettered in margin: 'Samuel Palmer, 17'. Other versions of this subject include a sepia drawing of the Shoreham period and a later painting in oils. Collection: David Dulley.

xx View near Red Hill. Pen and ink. $8\frac{1}{2} \times 4\frac{1}{2}$ in. Inscribed by Palmer: 'Nr. Red Hill June 24 1872.' Collection: Miss L. Twining.

xxi Cottage in Kent. Pencil $7\frac{1}{4} \times 4\frac{1}{2}$ in. On the back of the drawing is the signature 'S. Palmer'; also an inscription in the artist's hand: 'Willow Wood, Thanet'. Page from a sketch-book of 1819, originally in the possession of the artist's brother, William Palmer. British Museum.

xxii View from Richmond Hill. Pencil. $7\frac{1}{4} \times 4\frac{1}{2}$ in. Inscribed at top right: 'Frm Richmond hl'. On the back of the drawing is the signature 'S. Palmer', and an inscription by the artist: 'View from Richmond Hill, Surrey'. Page from the 1819 sketch-book. British Museum.

xxiii Sky Study. Water-colour, with reference numerals in ink. $7\frac{1}{4} \times 4\frac{1}{2}$ in. Inscribed in column on right. 'Reference 1 Deep Blue 2 somewhat lighter 3 Brilliant light of a silver yet warm hue melted and broken 4 into a fine neutral grey, the colour of all the shadowed clouds and lighter than the azure-5-may be produced by breaking 3 more into 4. 6—middle tint between 4 and 5. The lights soft on the azure and touched loosely to produce a fleeciness.' Page from the sketch-book of 1819. British Museum.

Notes on Colour Plates

Plate 1 Self-portrait of the Artist with Aureole. Oil on panel. $13\frac{1}{2} \times 9\frac{1}{4}$ in. Probably painted at Shoreham in 1826 or 1826. In the strict sense, this is not a self-portrait, but a study for a religious subject in which Palmer has used himself as a model, probably with the primary object of getting the luminous effect of a halo in oils. Certainly there is no saintly posturing here on Palmer's part. On the contrary, to judge by the entries in his journal at this time, he tended to regard himself very much as a sinner and a lost soul.

Plate 2 Hilly scene with Church and Moon. Water-colour, pen and tempera, fixed with varnish, on panel. $8\frac{1}{4} \times 5\frac{1}{2}$ in. About 1826. Inscribed on back: 'No 3 A Hilly Scene'.

Plate 3 The Magic Apple Tree. Pen and water-colour. $13\frac{3}{4} \times 10\frac{1}{4}$ in. 1830. In a description of this drawing, A. H. Palmer writes: 'Between the banks of a hollow, shady lane, a shepherd pipes to a few sheep as lazy as himself. Over these and beyond them is a church spire bosomed in trees, and in the background there abruptly arises a hill thickly covered with ripe corn which blazes in the sun like burnished gold against a very dark and thunderous sky. Overhanging the lane is an apple tree loaded to the extremity of every twig with bright crimson apples so numerous and so enormous as far to surpass the utmost stretch of possibility.'

Plate 4 Pastoral with Horse-chestnut. Water-colour and body colour. $13 \times 10\frac{5}{16}$ in. About 1830–1.

Plate 5 The Bright Cloud. Oil and tempera on mahogany panel. $9\frac{1}{8} \times 12\frac{1}{2}$ in. About 1833–4. On the back of the panel is a label inscribed in Palmer's hand: 'No 3 A Rustic Scene Samuel Palmer No. 4 Grove Street, Lisson Grove, Marylebone'.

Plate 6 The Goatherd. Pen and water-colour. $7\frac{3}{4} \times 11$ in. About 1836–7.

Plate 7 View at Tivoli. Water-colour. 12×16 in. This water-colour, one of the most successful of Palmer's Italian subjects, was probably painted after his return to England in 1839, though almost certainly based on a sketch drawn on the spot.

Plate 8 Study of Dandelions. Water-colour and body-colour on buff paper. $7\frac{1}{4} \times 5\frac{1}{4}$ in. *Circa* 1847–57. Most of Palmer's studies of wild flowers and plants date from his Kensington years; and his interest in what, by villa standards, were only weeds was to some extent an implicit protest against the showy pretensions of his geranium-growing neighbours.

Plate 9 Landscape with Dark Trees. Water-colour and body-colour. $16\frac{5}{8} \times 11$ in. This water-colour, which shows both the influence of Cox and De Wint, probably dates from 1850, when Palmer was desperately exploring the possibilities of a new style. Parts of a note written in this year are particularly relevant to this drawing, as, for example, the injunction: 'TAKE SHELTER IN TREES and try the always pleasing arrangement of white cloud behind ramification . . .' And later: 'Try something like the solid BLOCKS of sober colour in De Wint . . .' In this drawing, too, Palmer achieves at least two of the objects for which the new style was planned: 'To govern all by broad, powerful chiaroscuro. TO ABOLISH ALL NIGGLE.'

Plate 10 The Dell of Comus. Water-colour, body-colour and gum. $21\frac{1}{4} \times 29\frac{1}{2}$ in. Signed twice, the first signature covered by subsequent work on the bushes in the left foreground, the second placed further to the left. Exhibited at the Society of Painters in Water-colours in 1855, with a quotation from Milton's 'Comus'.

Plate 11 Landscape with Girl and Dog. Crayon and Chinese white, on cream paper. $8\frac{3}{4} \times 10\frac{5}{8}$ in. About 1875. Though Palmer seems to have used coloured chalk and crayon frequently for getting quick effects, few drawings in these mediums have survived. In this work, one of the freest and most 'experimental' of Palmer's later drawings, the white of the sky has been laid on thickly, as though by a palette-knife, and the bold crayon colour has all the vibrancy of French Impressionism.

Notes on Monochrome Plates

Plate 1 Hailsham, Sussex: Storm Effect. Water-colour. $18\frac{15}{16} \times 12\frac{1}{2}$ in. Inscribed by Palmer: 'At Hailsham SP'; and at right top corner: '1821 Sussex 7.17'. As Hailsham is not on the coast, it is probable that Palmer was staying there when the drawing was made. Though this drawing is based on an engraving by Turner of Rye, it is plainly the result of personal observation, and the numerals '7.17' inscribed at the top of the drawing may possibly indicate the time of day when it was done. (Palmer, like Constable, sometimes put the time of day on his drawings, but tantalizingly omits the year.)

Plate 2 Barn in a Valley (Sepham Farm). Pen and brush in Indian ink over pencil, heightened with white, on brownish paper. $11\frac{1}{8} \times 17\frac{5}{8}$ in. Probably one of a number of studies made for John Linnell by Palmer in 1828. Though 1828 is generally given as the year when these studies were made, Palmer had begun work of this kind for Linnell in 1824.

Plate 3 Oak Trees in Lullingstone Park, Kent. Pen and ink, and water-colour on grey paper. $11\frac{5}{8} \times 18\frac{7}{16}$ in. Signed lower right: 'S. Palmer'. Probably one of the studies from nature made for John Linnell between the years 1824 and 1828.

Plate 4 A Shepherd Leading his Flock under the Full Moon. Sepia. $5\frac{13}{16} \times 7$ in. About 1830–1. An example of Palmer's favourite mottled sky effect. In various forms it recurs in a number of his drawings. During a stay at Margate in 1845 he was particularly impressed by a cloud formation of this kind and subsequently based the sky of one of his large water-colours on what he called the 'Margate Mottle'.

Plate 5 Woman and Deer under a Full Moon. Wash and body-colour. $5\frac{5}{16} \times 3\frac{11}{16}$ in. About 1830. A characteristic example of Palmer's preoccupation with night effects and the arabesque patterning of dark boughs and leaves against a moon-lit sky.

Plate 6 Tintern Abbey. Pencil heightened with body-colour. $15\frac{1}{4} \times 9\frac{3}{8}$ in. 1835. Signed with initials and inscribed under mount. Another view of Tintern Abbey of the same date is in the Victoria and Albert Museum.

Plate 7 View of Linton, Devon. Pencil and water-colour. $13\frac{1}{4} \times 8\frac{3}{4}$ in. *Circa* 1835. Inscribed by Palmer at bottom left of drawing: 'From Castle Hotel, Linton, N. Devon'. And at bottom right: 'Nightingales'. Above this, another note by Palmer reads: 'Rather young trees but the dark hollows under them looking up stems'.

Plate 8 The Young Angler. Water-colour. $19\frac{5}{16} \times 14\frac{1}{4}$ in. Signed among the reeds at water's edge on lower left: 'S. Palmer'. Date uncertain, but perhaps painted in 1836. The tree formation and the arrangement of the stems suggest that Palmer has been influenced here by Raysdael and Hobbema, either directly or by way of the Norwich painters.

Plate 9 View on the River Machawy, Wales. Black chalk and water-colour, heightened with white. $11\frac{1}{2} \times 9$ in. Inscribed by Palmer at bottom right: 'On the r. Machawy, abt. a mile below Craig pwl du—and nr. its confluence with the Wye, Radnors. 5 July July 1837'. Dated again at bottom left: '5 July 1837'.
 The notes on this drawing and its precise dating indicate that it must have been done by Palmer on the spot, though no visit to Wales by him in this year has hitherto been recorded.

Plate 10 Classical Subject, possibly Narcissus and Echo. Water-colour. $7\frac{1}{2} \times 9\frac{11}{16}$ in. The date of this drawing is uncertain. The general style and feeling of it suggest the later Shoreham period, but it might also have been done soon after Palmer's return from Italy, perhaps in 1840 or 1841.

Plate 11 Pistyll Rhaiadr, North Wales. Water-colour, heightened with white. $13\frac{1}{2} \times 8\frac{1}{2}$ in. 1836–7. The meticulous detail of this drawing suggests that it was done as an exhibition work or perhaps with a view to its purchase by Crabb Robinson or the Rev. E. T. Daniell—both admirers of Palmer's waterfall subjects. Crabb Robinson records that Palmer called on him on February 20th, 1837, to inquire about Westmoreland Waterfalls. But apparently Palmer abandoned any idea of going North and made another journey to Wales instead (see Note on Plate 9).

Plate 12 View from the Villa D'Este, Tivoli. Water-colour and body-colour. 20×28 in. Probably painted shortly after Palmer's return from Italy in 1839. Exhibited at the Old Watercolour Society in 1845. Another version of this subject is in the Ashmolean Museum, Oxford.

Plate 13 Lulworth Cove, Dorset. $13\frac{1}{8} \times 8\frac{7}{8}$ in. Pencil and water-colour, heightened with white, on buff paper. Probably painted in 1841. A. H. Palmer states that his father, soon after his return from Italy, spent some time in Dorsetshire, painting and teaching. In the *Life and Letters* the date for this is given as 1844, but the evidence suggests that the visit took place three years earlier.

Plate 14 Christ outside Jerusalem. Oil on canvas. 41×30 in. Under a night sky with stars and a ringed crescent moon, the figure of Christ is seen against a mass of bluish-green cedars. In the middle distance a heron flies across a pool, and in the far distance the towers of a walled city stand out against a broken sky.
 This impressive and hitherto unrecorded painting almost certainly dates from the Shoreham period—perhaps 1828–9. For the head of Christ, Palmer has clearly used

his own features as a model and has produced, probably without consciously realizing it, a portrait of his youthful self.

Plate 15 Landscape with Rain-cloud. Water-colour and pencil, heightened with white. $9\frac{1}{2} \times 13\frac{3}{4}$ in. Perhaps dating from 1848–50, when Palmer was beginning his experiments in a freer and more naturalistic style.

Plate 16 Coast at Lynmouth. Devon, Pencil and water-colour, heightened with white on cream paper. $10\frac{1}{8} \times 7$ in. About 1848. Numbered '4' at top right corner. Inscribed by Palmer on sky at lower left: 'a little more sea'. Also in middle foreground: 'beach'. In Palmer's hand on back of drawing, 'Lynmouth'.

Plate 17 Study of Waves breaking on the Sea Shore. Black chalk. $6\frac{5}{8} \times 9\frac{15}{16}$ in. Probably done on one of the Devon or Cornish visits made by Palmer between 1848 and 1858. Inscribed by the artist at tide edge: 'Sand'. At the bottom of drawing, also in Palmer's hand, are the following notes: 'Windy day—tide coming in over sands. The two ridges below were terminated here and there by little waves. At B and C a leap of the foam about to fall—to the left of D—so: blown aside by wind—at AA the returned foam lifted upon the slope of the impending wave. The lowest part consists of returning wet foam—Cloudy day—under the bird central weight of foam pushing up each side.'

Plate 18 Tintagel Castle: Approaching Rain. Body-colour over pencil. $17\frac{1}{4} \times 11\frac{7}{8}$ in. About 1848–50.

Plate 19 Truro River. Water-colour and pencil, touched with white. $9\frac{7}{8} \times 5\frac{1}{2}$ in. About 1850. On the back of this drawing there are a number of colour notes in Palmer's hand; also the inscription: 'On Truro River Tuesday. June 5.0–7 p.m. After the journey Cadgwith all seems tame and noisy.'

Plate 20 Cascade in Shadow. Pen and water-colour. $18\frac{1}{4} \times 14\frac{3}{4}$ in. Inscribed by Palmer on back of drawing: 'Cascade in shadow near the junction of the Machno and the Conway. Drawn on the spot 1871'. Signed in left-hand bottom corner: 'Samuel Palmer' and inscribed above 'No. 7'. Exhibited at the Royal Water-colour Society, 1871.

Plate 21 Photograph of Samuel Palmer, 1863. The book that Palmer holds is a copy of Virgil's *Eclogues*, a gift from Edward Calvert. Of this photograph Palmer writes to Calvert: 'The photograph of that Virgil you so kindly gave me, it is but fair that you should have, so I enclose it. You can cut it out and throw the old man who holds it into the fire. The old man was obliged to sit, as it was for a set of the Water-colour members which Mr Cundall in Bond Street has published; so he took your Virgil in his hand; which, indeed, is seldom long out of it.'

Plate 22 Wooded Landscape with Stream. Water-colour and body-colour, on grey paper. $15\frac{1}{4} \times 11$ in. Numbered at bottom left '28'. Dated 'October 6th/60'. Private collec-

tion. Although no sketching tour is recorded in 1860, the scenery in this drawing suggests that Palmer may have visited Devon or Cornwall, or possibly Wales.

Plate 23 The Brothers under the Vine. Sepia wash with heightenings of white, blue and yellow. $6\frac{7}{8} \times 9\frac{3}{8}$ in. About 1872. The finished design is reproduced as Plate 10 in *The Shorter Poems of John Milton with Twelve Illustrations by Samuel Palmer, Painter and Etcher*, 1889.

> 'I saw them under a green mantling vine
> That crawls along the side of yon small hill,
> Plucking ripe clusters from the tender shoots.'
>
> *Comus*

Plate 24 The Eastern Gate. Sepia wash, squared for copying, with pencil notes by the artist on the scheme of light and shade. $10\frac{3}{4} \times 15$ in. Dated: 'May 1879'. The finished design is reproduced as Plate 2 in *The Shorter Poems of John Milton with Twelve Illustrations by Samuel Palmer, Painter and Etcher*, 1889.

> 'Right against the eastern gate
> Where the great sun begins his state
>
>
>
> While the plowman near at hand
> Whistles o'er the furrow'd land.'
>
> *L'Allegro*

In many of the preliminary designs for his etchings, particularly in the Milton series, Palmer combines in a remarkable way the imaginative qualities of his Shoreham work with a breadth and freedom of style reminiscent of Turner and Constable. These wonderful designs disprove, if anything does, the commonly accepted notion that Palmer's artistic powers declined in his later years.

Appendix

A Palmer Notebook

Over a lifetime Palmer must have accumulated a vast number of notebooks and sketch-books, of which only the two sketch-books in the British Museum and the little notebook discussed here seems to have survived. Other artists, of course, have expressed themselves revealingly in sketch-books and journals, but seldom in quite the soul-searching way that Palmer did. It was, in fact, their intimacy and lack of reticence that made the artist's son destroy these records in that fatal bonfire at Sennen, Cornwall, in 1910. To unburden himself in writing, to sketch out the things that possessed his imagination, was for Palmer a compelling necessity all his life. His notebooks and sketch-books, these repositories of hopes, misgivings, resolutions; of careful studies and scribbled visions, were as necessary to his artistic consciousness as the confessional is to the spiritual needs of other men. That is the tragedy of their loss, and if in the tangled animosities between the Linnell and Palmer families these records were destroyed because they showed too much the emotional side of Palmer, it is surely the cause of art itself that has ultimately suffered.

The present notebook unfortunately adds little to our knowledge of Palmer the artist. But it has its value as a personal document and it provides a unique commentary on Palmer's interest in the style and technique of other painters. This tiny pocket-book, which seems originally to have belonged to the Richmond family, was presumably used by Palmer in 1865–6, as these dates are written against some of the entries. In its extant form the book contains fifty leaves measuring $4\frac{7}{8} \times 2\frac{3}{4}$ in. The original covers are missing and also some of the leaves. Palmer has begun numbering the pages at 33 and has continued consecutively to page 123. Page 126 is placed out of sequence as the last page in the book. Here Palmer has made the enigmatic entry: 'The Park Catford

1 *First page of Notebook*

139

Bridge, Lewisham Ken[t] belongs to the blue dog.' In the middle of the book there are a number of unused pages, and in the numbered section pages 80, 96, 108, 110, 116 are also blank. Some childish scribbles here and there suggest that A. H. Palmer as a child may have made some contributions of his own.

Most of the entries have been made with a soft pencil which makes the writing, after over a century of rubbing, difficult or even impossible to decipher. This tiny book seems to have been mainly used for putting down on-the-spot notes about pictures seen at exhibitions, and some of the rubbing of the pages may be due to the fact that Palmer frequently carried the book about in his waistcoat pocket. In making these picture notes Palmer sometimes gives the exhibition numbers of the works, but omits to name the galleries where they were seen. For example:

'Solid opaque
443, 883'

'Stained drawings. Black or grey first then tints of colour—
456, 447, 384'

'Transparent way, Turner, de Wint, Havel[l], Fielding and others.'

Towards the end of the book there is, however, a reference to an exhibition held by the famous Victorian art dealer Ernest Gombart in 1866. Miscellaneous entries include times of trains to Epsom and the name of a doctor in Cork Street, London, whom Palmer perhaps intended to consult about his eyes.

The pitiful fees that Palmer got as an art master are shown in the following memorandum:

'Aug 22^d, 1865 Miss Kershaw first lesson. Of more received up to and inclusive of Saturday Dec. 2^nd, 1865. 2/6 per lesson—£1–5
2 sheets of tinted crayon paper 10d. 2 Conté crayon chalks 2d—£. . 1.'

On page 64 there is this curious note:

'Thinks the Col. might have the black and white bitch painted. *Myleptha Brindled.*'

'Sorais
[Here slight sketch of dog's hindquarters.]
eyes dark rich yellow brown.'

'Two middletoes of both back feet white. Both Col. North's dogs.'

One of the few entries in ink is a four-stanza sea-ballad entitled 'Under the Black Flag'.

'Oh, ever a rover's life for me,
A gallant bark and a rolling sea;
On my own proud deck like a king I'll stand,
While brave hearts bow to their chief's command.'

This may be something that Palmer has copied down, or it may possibly be one of his own

compositions. In the Ivimy sketch-book in the British Museum, Palmer has tried his hand at poetry in the Miltonic style, but here he may be attempting verse in a lighter vein. It is perhaps worth noting that in 1860 'A Book of Favourite Ballads' was published, two of the plates being provided by Palmer. But the most interesting sections of this note-book are those in which Palmer has made detailed analyses of works by other artists, with thumb-nail sketches of the subjects added to his notes. The cursory nature of the writing and the almost complete lack of punctuation suggests that these notes were hastily jotted down in the crowded *milieu* of exhibition rooms. In making transcripts here I have added punctuation and capitals in many cases to improve the sense.

Only on the first page of the book do Palmer's notes have any reference to his own work. The list of subjects set out here are clearly intended as a personal memorandum. The sketch of Christ carrying water, the tiny blotted ink sketch of what is presumably the Palm subject and the final slight pencil outline of a girl wiping a child's eye—these, and a slight pencil sketch of grass and herbage on a later page, are the only original drawings in the book.

'Subjects from the life of Our Lord as Boy: carrying water from the well, figures looking on; or figures gossiping, the[y] knowing not that God is near.'

'Subjects.
Palm Sunday—Christ giving Palms (kissing the Cross)
A Daughter of Eve looking at the branch of an Apple tree growing over a garden wall into the road side.
A girl tying child's scarf, or a better class child out of its latitude [?], careless of self, but kindly to others.
On the sands cockle girl wiping an eye.'

A surprising entry is a long analysis of the technique of William Orchardson's picture, 'A Hundred Years Ago'. This painting was not exhibited in the Royal Academy until 1871, so if we assume that Palmer used the notebook in 1865–6, he must have seen this picture, or a sketch for it, on some previous occasion. 'Orchardson. 100 Years Ago. (William Orchardson 1835–1910.)'

2 *Verso of first page of the Notebook*

Seems all done in one day, no joining or glazering [?]. Flesh laid in first stiff white, then pure pearly, stiff tints dragged over, but the flesh realized at once on this: the ground slightly showing, thereby background all streaks. With the brushwork stiff colour at once. A wee bit fractious, the background is stiffly painted. It may have been laid on first then tinted slightly. Some parts seem to have been juicely worked and lights glazed over some parts which were laid a little darker. The head of hair tells dark against the wall. The lights of flesh is [*sic*] perhaps a little lighter than wall. Lakey tints for flesh, bones through like bituminish[?] shadow. Flesh peony in parts—tints of this kind seem passed over half-tones of flesh. Cool grey shadows on wall a good deal removed from white. Cologne earth and B$^{rn.}$ Pink might make it. The earthen floor is a sweet pearly ashy colour. Cologne earth and Vandyke B$^{rn.}$ might make it.' [Here small sketch of seated woman, with colour notes.] Note continues: 'Child's dress flesh colour, red stockings.' Over a slight indication of a shaded area, the words—'bituminous green'. And below this: 'Woman's dress modification of Cologne earth. Van B$^{rn.}$ Little stripes [Here stripes indicated by a few short pencil hatchings] lighter and lakey touches. Broad stripes of bitumen brown with yellow okr. mixed—in fact bits of broken colour drag[g]ed about.'

Palmer follows this note on Orchardson's picture with another on the style of the Yorkshire artist Francis William Topham (1809–77), who became a member of the Old Water Colour Society in 1848.
'Topham

His manner is not so much stipple as a look of it. He seems not to let any wash stop without taking the top surface off it, even in flesh. And moreover his background is touched after it is done with a broad [Here rough outline of broad, round brush tip.] brush and done in a fluffy manner, but very little except in foliage. The other parts, such as earth and shadows, are massive wash$^{d.}$ or varied, depending on the first rubbed paper. His greens are generally yellow, inclined to gamb$^{g.}$ and yellow mixed. A little blue. Some of his shadows on earth are first put in rich and then done cool, blue passed over here and there. Washes in the background are broad and massive washes. Only the . . . [The writing at this point is much rubbed and only a word or two can be read.] . . . there seem a few blottings out here and there. Scarcely any attempt to make grass except in masses and a few small bits taken out. All seems to melt off from his figures, but nothing darker than wash-leather except in a small touch or two. His rocks are inclined to blue, remember[?]. Indian R$^{d.}$ looking indeed grey in shadow. The lights seem cut out and a little . . .' [Here the writing becomes completely illegible through rubbing.] After this note there is a pencil sketch, with written colour notes, of a woman arranging her hair—probably a copy of a work by Topham.

Another note describes a figure subject by William Shakespere Burton (1824–1916).
'Burton. An Italian Girl. White head-dress and schemise [chemise] bluish white. Face brownish. A portion of lakeish apron brn. and French blue, dappled up and down with yellowish brown. Skirt vermillion Rd. with Indian half-tones, a cerulean skirt seen under this with yellow green light. Copper water jug yellowish. [Here sketch of subject.] His flesh like Topham's, with nice grey worked in, in lights there is no stipple, but only like drops of coloured water. No body of colour in it. [Here some slight indications of Burton's stipple form with a few explanatory comments.] The stipple in lights of grey wall is nearly as broad, but is not quite so apparent—seems more as though the lights were taken out at each side. Yellowish

tones put in amongst purplish greys.'

On page 48 of the numbered section, under the heading 'Mrs Masson', Palmer has made some notes which suggest that he had been commissioned to paint a portrait, or perhaps copy one.

'Mrs Masson. Complexion about Mrs G.,[1] a little warming rose in cheeks. Hair has been nearly black: a few grey hairs intermixed, very few. The flesh is seen for a little way up. [Here slight indication of hair line above forehead and outline of nose.] A little warmish colour on forehead. Eyebrows tell, darkish—not quite so black as hair.
Eyes darkish brown but warm—
Brooch a little diamond in centre, mostly dead gold;
Very little under eyelashes. Chin warm as the other warm parts.
Make the skin a little warm.'

The last note of any length about fellow artists is on Birket Foster (1825–99), a member of the Old Water Colour from 1862.
'Birket Foster. A sun-lighted plain. Seems first washed in, perhaps it may be with little cobalt gamboge and white, making it pay enough for lights; then washed or broad touches—gamboge, raw Sienna or yellow gambg. This underground joy[?] palpitating through. In the distance there seems a little solid touch put on. He seems to use sepia in his shadows of distant trees. The lights, though warm and yellowish, seem diluted gently with blue, being also used were [sic] required. The sky has no body colour in, but is soft and fluffy, the clouds being shaded. [Here slight pencilling of cloud form.] Ivory Bk. Cobalt warm blue of sky. Cobalt most. The light part of clouds looking[?] as though washed with yellow ochre. Slightly dark in shadows of clouds, darker than blue of sky, these being colour of pale starlit[?] sea, a medium between colour of sky and shadow of clouds, except in foreground where it is soft[?] in

3 *Page from Notebook. The sketch is a copy by Palmer of a figure subject by William Shakespeare Burton*

<hr />

[1] In all probability Mrs Gilcrist, wife of Alexander Gilcrist, the biographer of William Blake.

reflections and a little purple in shades, as though some dark clouds were reflected. [Here a few pencil lines to suggest the rounded tops of trees.] Touch in distant trees coming against sky like drops of coloured water. Touches up and down.'

Almost at the end of the book there is a reference to the work of Frederic James Shields, today almost a forgotten artist. Palmer had been impressed by some picture by Shields which he had seen, particularly by the painting of a chair—possibly the chair in Shields's water-colour, 'The Beehive Maker'. In a few lines Palmer makes a descriptive analysis of Shields's colouring and technique. But for Palmer, Shields may have been a more significant figure than the brevity of this note suggests. Shields, it seems, was an ardent admirer of Blake, and in later years was regarded as an authority on his work. Indeed, he helped Mrs Gilcrist in the production of a second edition of her husband's *Life of Blake*, which appeared in 1880. About this time some volumes containing 530 designs by Blake for Young's *Night Thoughts* had come to light in a provincial sale, and Mrs Gilcrist called in Shields to inspect and authenticate the new discovery. Shields wrote descriptive notes on these designs, which were included in the second edition of the *Life*. Of Shields's contribution to the new edition, Rosetti wrote to Madox Brown:

'The new Blake volumes are truly splendid. Shields had made the most wonderful cover from a design of Blake's, and has written a long paper on Young's Night Thoughts series, which reads as if he had been writing all his life. He has drawn a most interesting plate of Blake and his wife from Blake's Sketches, and a separate one of Mrs Blake from another sketch of Blake's. In fact he has half-made the book.'